DRAWING
TECHNIQUES

DATE			
OCT 1996			

Contents

INTRODUCTION

Drawing is an art form in its own right, and drawing skills are essential in almost every kind of artistic expression. Whether it is used to communicate your personal ideas and express your feelings, or as a means of planning paintings or designing craft projects, the importance of drawing is self-evident.

Drawings can take many forms, be created for a variety of reasons, and use a wide range of tools, media and techniques. A drawing can be composed of a single line or, contrastingly, posed of a single line or, contrastingly,

it can involve colour, a combination of methods and media, and great detail. Whether a cartoon, a sketch, a highly resolved study or a detailed illustration, and whether scratched into a rock face or printed by a computer, the scope for drawing is tremendous.

Remember that drawing is often a mixture of fact and feeling. The idea or choice of subject matter is important, and so is the means by which this is realized in a graphic way. But what really identifies a good drawing is that extra ingredient of personal interpreta-

tion, sensitivity, emotion or inspiration – in other words, individual style.

The ability to express your ideas in a personal way evolves from three main factors: technical skills; observation; and interpretation. Practice, perseverance and enthusiasm all count a good deal in helping to develop your own way of working.

Because you should regard drawing as an original response to an idea, there is no special or 'correct' way of working. Whilst the foundations for success lie in developing some confidence with handling a wide variety of subjects and materials, another factor plays an equally important part – observation. The ability to draw relies to a large extent on the ability to look and understand. Artists need to be inquisitive and to look with perception.

For the beginner, copying exercises and ideas may help to start with, but don't make this a habit. Set up your own still life groups, and find your own landscapes and other subjects so that you can work directly from life. Combine such work from observation with a desire to find out as much as you can about different materials and techniques. In this way you will soon be able to select the approaches which work best for you and which convey the sort of impact and intentions you have in mind.

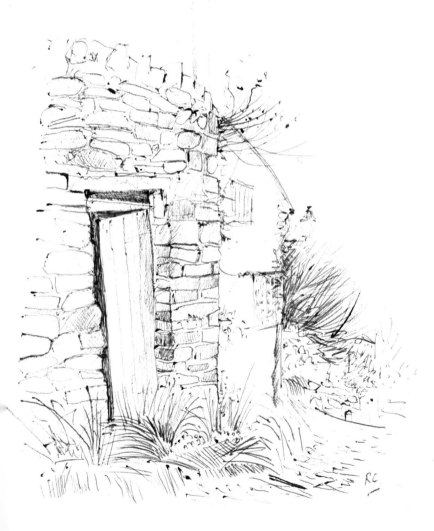

Old Doorway *Drawn in ball-point pen, this free-flowing sketch was made with variations of pressure and a number of different techniques to create contrasts of line, tone and texture.*

Introduction

Each new drawing you make should be something of a discovery – about the subject, about the method or drawing tool you are using, or even about yourself. I have structured this book so that it will help with your discoveries, finding out first about the materials and equipment, then the wide range of techniques available, working in colour, and finally discussing how to organize other elements and aspects of your drawings so that they work successfully. Tips, summaries, exercises and step-by-step projects are used to support the practical guidance in the text. Above all, I hope you will find the book instructive and encouraging, and that it will help you to develop the confidence to explore and enjoy the wonderful world of drawing.

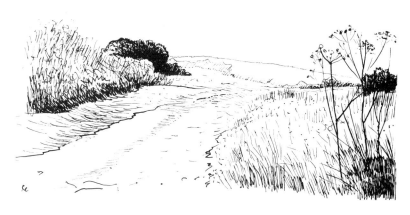

South Downs Way *A fibre-tip fineline pen used on thin cartridge paper is a good technique for quick landscape sketches such as this one. Sketch in the main areas with faint broken outlines, then work from the distance to the foreground. Try to choose different pen techniques to match the surface textures and tones of each area. Experiment with a variety of push and pull strokes with the pen held in different positions. Vary the pressure to create a range of tones. Contrast 'open' areas with those which are worked in more detail.*

Summary

■ Drawing is a way of expressing ideas and information to other people.
■ There are many types of drawing, each with different aims and intentions.
■ Drawing is looking and understanding before it is interpreting and imagining.
■ A knowledge of different materials, techniques and approaches helps to develop confidence to explore a personal style.

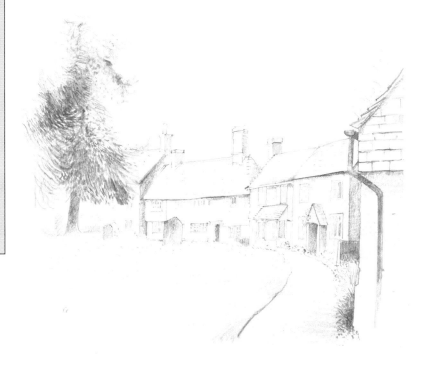

Village Green *6B, 2B and HB pencils were used here to give the range of required tones and necessary definition.*

MATERIALS AND EQUIPMENT

There are lots of ways to draw, but whatever the technique – whether an image scratched on to a cave wall with a flint or a subtle study in charcoal on paper – most drawings involve little in the way of basic materials and equipment. Indeed, most are made with pencil on paper, and this is all you need to start with.

The pencil medium is versatile: it will allow you to explore line and tone as well as many of the other techniques and ideas described in the pages of this book. However, as you gain confidence don't be afraid to try out a wide range of other media and tools as well. Drawing is all about discovery, and this is at least in part related to finding out which media best suit the way you want to work and the ideas you want to express. Practise the basics, but be adventurous as well!

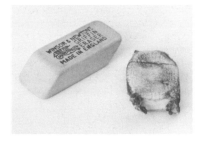

Erasers *You will notice a confusing array of erasers displayed in art-supply shops and will probably wonder which sort will be most suitable for your work. The two shown here are the ones I use most frequently and have recommended for many of the step-by-step projects in this book. A flexible, wedge-shaped rubber eraser (left) is ideal for pencil drawings, while a malleable putty eraser (right) suits charcoal, chalk, pastels and similar soft media.*

Learn to use your eraser in a positive way as another drawing tool – you can lift out highlights, slightly reduce or blend tones and sharpen edges with it.

MATERIALS

As a basic stock for most of the work covered in this book you will require the following items. You can add to these as the need arises.

■ Ten A1 sheets of 150gsm cartridge drawing paper, cut to the required shapes and sizes.
■ Two A1 sheets of 300gsm watercolour paper. For wash and texture work.
■ Several sheets of coloured pastel paper.
■ An A4 spiral-bound cartridge sketchbook.
■ A small notebook with smooth, plain paper.
■ HB, B, 2B, 4B and 6B drawing pencils.
■ Water-soluble or Conté coloured pencils.
■ Sticks of charcoal and a medium charcoal pencil.
■ A box of wax crayons.
■ Fine fibre-tip pen (black), marker pen (black) and a mapping pen with Indian ink.
■ Watercolour brushes nos 2 and 6, and a no. 6 round hog brush (for stippling).
■ Small tubes of red, yellow and blue watercolour or gouache paint.
■ The essential ancillary equipment shown on page 9.

General Equipment *This 'starter' set of equipment includes some drawing and sketching pencils, one or two water-soluble and coloured pencils, a stick of charcoal, a felt-tip marker and a ball-point pen. These will give quite a scope for drawings in the cartridge sketchbook. The brush and clean water will enable lines and tones to be worked on damp paper or, as with those made with water-soluble pencils, to be diffused and worked as wash. All of this equipment (except the jar) will fit into the small box easel/carrying case.*

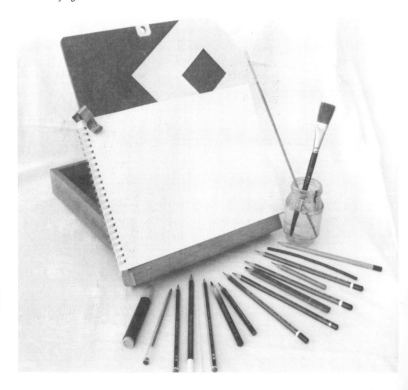

Sketching Equipment *For many, part of the thrill of drawing is to get out and about, discovering new ideas and at the same time enjoying the fresh air. There is plenty of useful equipment available for sketching trips – invest in what you need according to the frequency of such work, the degree of comfort you want, and the type of drawings you envisage making.*

I have found the sort of seat/backpack shown here useful for carrying a whole range of equipment as well as a day's food supply! Sometimes I use a lightweight folding easel similar to the one illustrated.

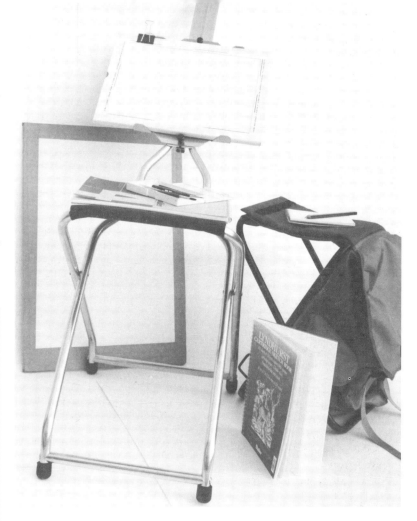

Choosing Equipment

■ A good art shop will be able to offer you advice and will even demonstrate some of the materials for you. Look for good-quality products from well-known manufacturers.

■ You don't have to buy whole sets or boxes of pastels, crayons and so on. Try just one or two colours to begin with. Once you have experimented with these, and if you decide you like the medium and you want to explore it further, then you can add to your basic range of colours.

■ Look after your materials and equipment. Store paper flat, clean and 'point' brushes after use and store with bristles upright, and protect soft materials such as pastels with foam rubber or cotton wool.

Brush and Wash Techniques
The equipment shown here will give you tremendous scope for line and wash, brush and wash, stippling, texture and other techniques. General washes can be applied with a flat wash brush or a small natural sponge.

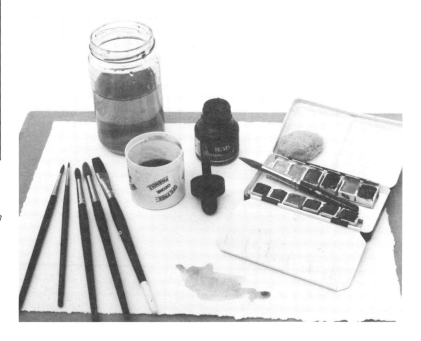

Paper

The choice of paper is a significant factor in determining the eventual outcome in a drawing. You will soon find that some types of paper allow, and even encourage the sort of response and effects you are after, whilst others will greatly inhibit a similar approach. A thin, smooth layout paper, for example, whilst fine for pen lines, will prove extremely difficult as a support for wash techniques or work in pastel and charcoal. As with so much in drawing, it is a question of experience. Gradually you will learn to know which papers will suit which media and effects.

For the projects in this book I have deliberately kept to four main types of paper: cartridge paper for pencil drawing, charcoal, and most wash and experimental techniques; smooth white layout paper for pen and ink work; Ingres paper or Winsor & Newton Artemedia paper for pastel and charcoal drawings; and medium-quality (300gsm) watercolour paper for texture and wash effects. I suggest that you start by using these papers, gradually introducing others as your drawing develops and demands them.

You will find that each side of a sheet of paper has a slightly different surface. Most manufactured cartridge paper, for example, has a smooth surface on one side and a slightly more uneven surface on the other. Usually we choose the uneven surface. To check this, hold the sheet of paper up to the light and bend one corner over to compare the surfaces. Watercolour papers are generally available in three varieties: hot-pressed (HP), which is smooth; not hot-pressed (Not), which is semi-rough; and rough. Think also about the advantages of using tinted and coloured papers to enhance effects.

Papers *Get to know a range of various types of paper and how each responds to different media. Keep experiments and test pieces for future reference, if necessary noting on the back the type of paper and medium used.*

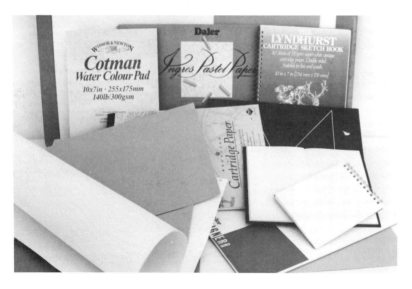

Stretching Paper

For wet techniques, such as spraying, brush and ink work, wash and so on, it is best to 'stretch' the paper first. This will apply to all papers except heavy quality watercolour paper. Stretched paper will dry flat, whereas unstretched paper will usually dry in a distorted, uneven way.

You will need drawing paper of the appropriate size, a drawing board, 50mm (2in) gummed brown tape, scissors, a sponge, and a clean sink or deep tray of water. Ensure that the paper is at least 30mm (1.2in) smaller all round than the board. Cut a strip of gummed tape for each side of the paper (allow for a slight overlap at each end).

Pull the paper through a tray of clean water (as in the photograph), or soak it under a running tap or in the sink. Make sure that both sides of the paper are really wet. Quickly place the sheet of paper flat on the drawing board.

Dip the sponge in water, and use it to wet the back of each brown paper strip. Press these into place lightly along the edge of the paper. Let the gummed strip follow any ridges in the paper. When all four strips are in place, run a wet sponge over them to double-check they are wetted enough, and wet any overlaps of tape to the underside of the board. Be sure that you do not crease the drawing paper in any way.

Leave the board flat in a warm room or sunny spot to dry. You can speed up the drying process with a fan heater, but don't overdo it – paper which dries too quickly sometimes tears around the edges!

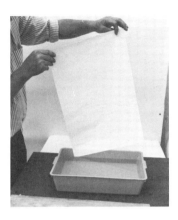

Stretching Paper Step 1 *Soak the paper in clean water, making sure that both sides are really wet.*

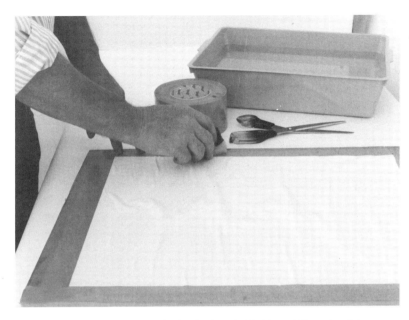

Step 2 Place the wet paper on the drawing boards. Working quickly, wet each brown paper strip in turn and place around the edges. Press these in place, making sure that you do not crease the paper.

Ancillary Equipment *The more drawing you do, the more you will gather into your general equipment other tools and items which help the way you work. You will see from the photograph the sort of additional items which might be useful. Working clockwise around the photograph from top left to bottom left: a drawing-board clip for keeping paper in place whilst working; gummed tape for stretching paper; a paper 'stump' for blending soft tone work; bulldog clips; a craft knife; pins; a card viewfinder to help with composition and selecting ideas; a cotton bud for blending; straight-edges; pencil sharpener; scissors; and tissues for blotting wash work.*

Paper Sizes and Weights

■ Art shops will sell a single sheet of paper; manufacturers produce it in quires (25 sheets) and reams (500 sheets).

■ The weight of a ream, converted into grams per square metre (gsm or gm²), indicates its thickness. Thus, 70gsm designers' paper is smooth and thin, while 640gsm watercolour paper is rough and thick.

■ For most projects in this book, look for 150gsm cartridge paper (pencil); 70gsm marker pad paper (pen and ink); 300gsm watercolour paper (wash and texture); and 160gsm Ingres paper (pastel and charcoal).

■ Paper sheet sizes are mostly available in ISO (International Organization for Standardization) sizes, with each size in the list below exactly half of that above:

A1 – 840 x 594mm
A2 – 594 x 420mm
A3 – 420 x 297mm
A4 – 297 x 210 mm

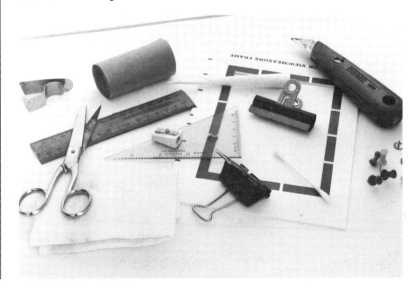

Getting to Know Your Materials

Familiarity and confidence with a range of drawing media will prove a valuable asset, as it means you can select the best approach for each subject and idea you want to draw. Choosing the most appropriate medium for a particular drawing is a matter of experience and practice. Help yourself gain an understanding of drawing tools and media, as well as a breadth of skills and techniques, by trying out as wide a variety as possible.

Experiment on different types of paper, see what marks and responses each medium makes, and get used to handling it.

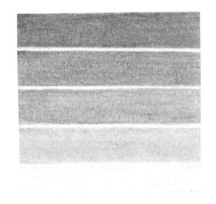

Making Marks *Notice the range of marks made here with a single pencil. Apply this sort of exploratory test to each new medium. Try holding the pencil in different ways, experimenting with different pressures and surfaces.*

Pencil Tones *Try this exercise with other media such as charcoal and crayons. Note that with some media (such as pen and ink) you will need to employ a dotting or hatching technique to suggest different tones.*

Pepper (1) *This study of half a pepper was made with a 3B pencil on 110gsm cartridge paper. This particular combination of medium and paper meant that I could exploit the tonal qualities of the subject and indicate some detail. In this way, I could build up really good dark tones where necessary, using blended and more subtle effects elsewhere.*

Pepper (2) *This version was drawn in pen and ink on smooth cartridge paper. Although it is a bold and effective result, the pen dictates a very linear approach, so this time I could not achieve the same degree of subtly blended shading as I could with the pencil. The pen is, however, good for detail, definition and strong tonal contrast.*

Pepper (3) *This version of the pepper uses a charcoal pencil on heavy quality watercolour paper. This time, whilst it was difficult to achieve clearly defined outlines and solid tonal areas, the choice of paper brought out the texture of the subject. Compare the three drawings and notice how the combination of medium and paper is important.*

Getting to Know Your Materials

Houses at Clovelly – Step-by-Step (1–3)

**MATERIALS
For Step-by-Step**

- B drawing pencil.
- 4B drawing pencil.
- Putty eraser.
- 150gsm cartridge paper.
- Fixative.

Step 1 *For a view like this, start by drawing in a faint horizon line, then indicate one or two verticals and perspective angles so that the general framework can be established. Keep these guide-lines weak and unobtrusive; some will disappear into the drawing but others may need to be erased later. Look at the spaces as well as the positive forms, and constantly compare the position and size of each part to the others.*

I used the B drawing pencil to build up the outline in this way. If you lack confidence, feel your way into the drawing gradually. Don't make any lines too bold until you are sure about them, but notice that I have emphasized some lines in order to begin to suggest some depth.

Step 2 *Here I started to explore the potential of both pencils. Notice the source of light and how it plays across the subject, and begin to block in the tones accordingly. Exploit the tonal range of each pencil, using the B pencil for lighter tones and the 4B for soft texture and the darker areas.*

Step 3 *The 4B pencil will allow you to strengthen the tones markedly and sharpen up the outlines where necessary. Keep the pencil sharp. There is quite a range of pencil effects here, from solid tones to hatching, detail and touches of texture. Look for a similar subject which will help you try out different media in this way.*

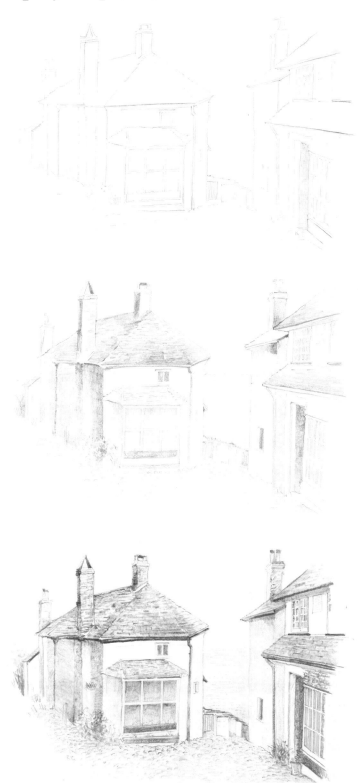

EFFECTS WITH DIFFERENT TOOLS AND MEDIA

You will find that your drawings work best if you select the most appropriate media and techniques for the sort of effects and impact you want. Each drawing medium has its own particular characteristics, strengths and limitations. Therefore, practise and experiment with a wide variety of media so that you develop confidence and a breadth of knowledge and experience.

Pencils

Always choose good-quality drawing pencils from well-known manufacturers. These can be relied upon to give a quality and sensitivity of line and tone which cannot be equalled by the cheaper brands sold at stationers.

In terms of hardness, drawing pencils usually range from 2H (very hard/light) to 6B (very soft/dark). For normal drawings it is unlikely that you will need anything harder than an HB. This will give you sharp, defined lines and light or grey tones. Most artists prefer to use softer pencils, 6B being ideal for quick sketches and expressive line work, as well as providing a range of tones up to very dark. The feel and response of pencils varies from make to make, so try out various kinds until you find the one you like best. Modern pencils are made of bonded graphite glued into a casing of soft wood.

Gradually, you will find that you need more than one type or degree of pencil to complete your drawings effectively, as, for example, in a subject which includes a range of soft, blended tones as well as sharp, defined areas and precise lines and details. Additionally, carpenters' pencils and graphite sticks are ideal for quick, general sketching as well as for blocking in large areas of tone. Look at the demonstration on the opposite page to see how these combine very successfully with ordinary drawing pencils.

Some black coloured pencils and sketching pencils are water-soluble. This means that when wetted they can be blended out and diffused into the surrounding area or, alternatively, used to create an underlying wash for further work in a more precise, linear fashion.

Perhaps because it is one of the most obvious drawing implements, the scope of the pencil is often underrated; in fact, it will give a surprising range of effects and is probably the medium which will best reflect your drawing ability. Pencils are very sensitive to the sort of pressure you apply, so choose your pencils to match the way you work. And, as with all media, choose the paper carefully, as this will have its influence on what can be achieved.

Rumpled Trousers *This was drawn with a 6B pencil, which, when used with varying degrees of pressure, will produce a suprising range of tones. I've kept the pencil sharpened to a fine point for the more definite lines. The general shadow was created with a water-soluble pencil, which was applied dry and then wetted in with a soft brush and clean water, giving a watercolour-wash effect.*

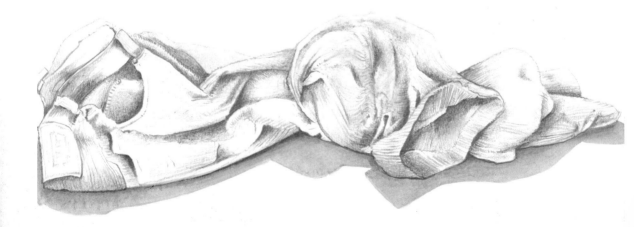

Bridge – Step-by-Step (1–3)

Step 1 The main outlines were drawn with an HB pencil using light pressure and, where necessary, broken lines or a series of faint lines. I began to think about the distribution of light and dark by sketching in a basic tone for the darkest areas with a broad carpenters' pencil.

Step 2 The underside of the bridge had the darkest shadows, so these were blocked in with a 5B pencil to fix the tonal key for the whole drawing. Sharpened to a fine point, the 5B pencil was also used to put in some of the middle-distance grasses and detail, which were indicated with hatched and point techniques. The flat strokes of the carpenters' pencil proved ideal for the stonework on the bridge and for enhancing the dense tone of the foreground.

Step 3 Notice that the drawing was developed in an overall way, rather than piece by piece. Working from distance to foreground, details, textures and tones could now be finalized. The light toning of the sky made with a carpenters' pencil was modified by lifting out parts with a putty eraser. All three pencils were involved in the finishing process: the HB for outlining the fencing, other specific lines and middle-ground grasses; the carpenters' pencil for texture and medium tones; and the 5B pencil for sharp lines and heavy, dark tones.

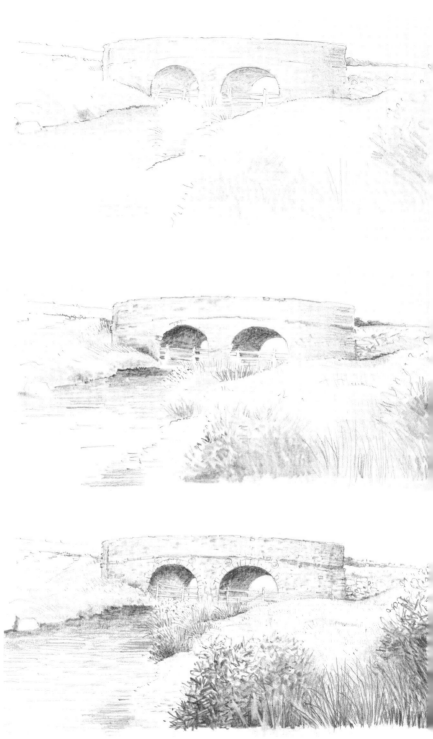

MATERIALS
For Step-by-Step

- 90lb cartridge paper.
- Carpenters' pencil.
- 5B pencil.
- HB pencil.
- Putty eraser.
- Fixative spray.

Pens

There are plenty of different kinds of pens from which to choose, so try out as many as you can. A little practice shows that each type of pen behaves in a certain way, producing its own quality of line and range of techniques. You will find that it is possible to combine several pens within the same drawing to create contrasting effects. Also, by exploiting the influence of different weights, varieties and colours of paper, the scope for pen drawing is considerable.

Pens fall into three main categories: dip-pens, which are used in conjunction with a separate ink supply; reservoir or cartridge pens; and disposable pens, such as the various makes of fineline fibre and felt-tip pens. In general, dip-pens offer the best potential for expressive, individual work. This is partly due to their unpredictable nature: they do not have the same steady, controlled flow of ink that other pens have. The nibs of dip-pens are also more sensitive to the pressure applied and the direction and angle at which they are used. Mapping pens are inexpensive and ideal for small drawings and fine linear work. Other dip-pens have interchangeable nibs of different widths, and you can also use calligraphic pens where contrasts of thin

Pens *A selection of pens suitable for drawing and sketching. From left to right: art pen and technical pen, both of which have replaceable cartridges of ink and are available with different nib widths; dip-pen and mapping pen, both used with Indian ink or other types of drawing ink; fineline fibre-tip pen; felt-tip pen; and ball-point pen.*

Boats *This sketch was made with a ball-point pen, and exploits the use of line to create contrasts of tone and also to suggest different surface effects and movement. Note how the more intense tones were achieved by making a succession of lines packed closely together.*

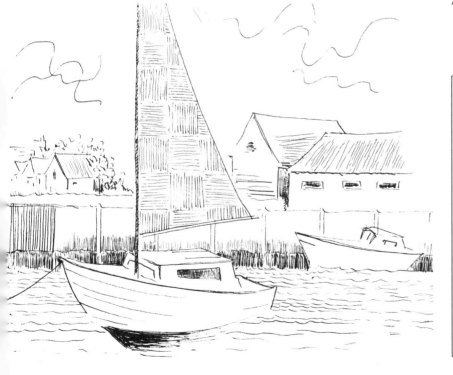

Paper for Pens

Make some tests on an offcut of paper to check the effects you want.

- Cartridge paper.
- Ingres paper.
- Calligraphy paper.
- White bond paper.
- Layout pads.
- Marker pads.
- CS10 paper.
- Smooth white card.
- Heavy quality and coloured papers for broken line and textural effects.

and thick strokes will be helpful. You can even make your own dip-pens by sharpening small sticks or lengths of reed or bamboo. All these pens are used with Indian ink or coloured drawing inks which can be diluted as required.

Technical pens, such as those marketed by Rotring and Staedtler, are best for meticulous detail and illustration work. They have a replaceable cartridge of ink and interchangeable nibs. Also try out art pens, ball-point pens and fibre-tip pens. All of these are extremely good for sketching outside as they do not need separate bottles of ink or other equipment, and consequently allow very quick, direct work. Cheap ball-point pens tend to clog and form occasional blotches, but the well-known quality makes with replaceable refills are reliable and quite sensitive drawing tools. I often sketch with a black ball-point pen of this type.

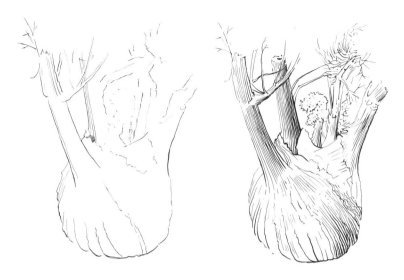

Fennel (1) *The main outlines were worked in with a mapping pen and Indian ink over a faint pencil drawing on 96gsm cartridge paper. As the form was described by means of lines rather than tones, those outlines in shadow required greater emphasis.*

Fennel (2) *More pen lines were added in such a way that they not only created an impression of three-dimensional form, but also implied something of the character and detail of the subject. For this, the pen must not be overloaded or used too vigorously, and touch and pressure are all-important in achieving lines of the correct strength.*

Winter Trees *This free, sketchbook drawing was made with an art pen. No initial pencil drawing was necessary, just a few faint pen strokes to indicate the position of the main shapes. Pressure was again a key factor in creating contrasts of line and tone. Notice how the pen was manipulated to create different effects, from dotted textures and hatched and meandering lines to loosely worked heavy tones.*

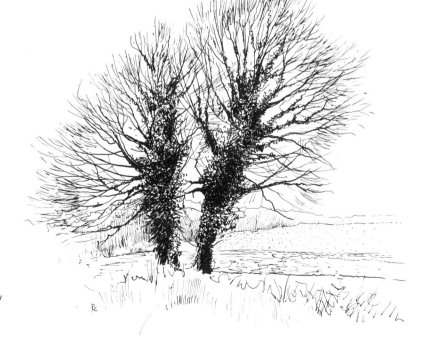

Inks and Paints

There are two main ways in which you can use inks and paints in your drawings. First, you can draw directly with a pen, brush, length of card or other implement which has been dipped in ink or paint. And second, you can use washes made from diluted ink or paint for the general background tones or textures in a drawing which will subsequently be developed with other media.

Brush techniques work well for large-scale, spontaneous contour drawings, as well as for composition roughs and sketchbook ideas. Brush and wash methods combine most effectively with more precise work in pen and ink. The washes can be laid in first, with the pen lines worked over these when they have dried, or weak washes of tone or colour can be added to a complete pen and ink study – particularly if waterproof ink has been used. Areas of wash also form a good foundation for subsequent pencil, charcoal or pastel work.

As with pen and ink drawings, those made in brush encourage a positive and confident approach; there is little scope for making alterations or eradicating mistakes. Select good-quality

watercolour brushes for flowing lines and general drawing, and stiff-haired hog brushes for dry brush and stipple effects. The dry brush technique works best on heavy quality paper. Use just a little paint on the hog brush and drag it lightly across the surface of the paper so that it catches here and there to form a broken tone/textural effect. For stipple, hold the brush vertically and stab lightly up and down to offset a speckled texture.

A well-laden watercolour brush is probably more sensitive than any other drawing implement to the way it is handled and the pressure applied: lines can grow from very thin to very thick within a single sweep of the same brush. However, as with any drawing tool or medium, you need to experiment to see just what range of marks and effects is possible.

Mix the ink or paint in a shallow container. You can use any water-based paint, Indian ink, or coloured drawing inks. Dilute to the required strength of colour and test on a scrap of paper. In the main, washes need to be very weak, so add plenty of water to just a few drops of medium. Apply washes with a flat, wide one-stroke or wash brush. You can also dab in tone or texture with a small piece of sponge or a stiff-haired brush. Experiment with different papers, including coloured papers. Work on stretched paper (*see page 9*) if large areas of wash are involved.

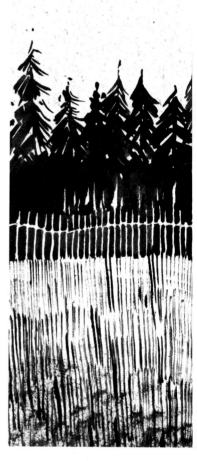

Forest *Try an idea such as this one to experiment with a number of ink effects.*

For the sky area I used a spattering technique to make a mottled, spray effect. Dip an old toothbrush or stiff-haired brush into some ink or paint, and prop the paper up almost vertically. With the brush held a little distance from the paper, pull back the bristles with your forefinger, so creating a shower of spray.

The trees were formed by direct brushwork in Indian ink, whilst the foreground consists of impressed lines over an applied texture.

The texture was dabbed on with a small piece of cloth dipped in ink, and the lines were made by pressing down with a short length of card dipped in ink.

Church *Small brush drawing made with a no.2 watercolour brush and slightly diluted Indian ink.*

Inks and Paints

Buildings – Step-by-Step (1–3)

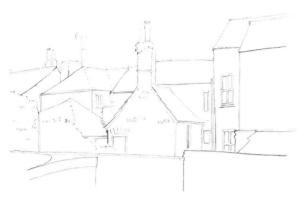

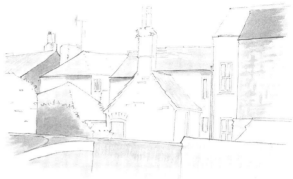

Step 1 *The main lines were drawn in with a sharp B pencil so as to establish an accurate working outline. Where necessary, some lines were given a stronger emphasis.*

Step 2 *Next, the areas of wash were added. The wash was made from extremely diluted Indian ink. When dry, some parts received one or two more washes to build up the required strength of tone.*

Step 3 *The wash tones were then worked over with a sharp HB pencil for defined lines and brickwork, and a much softer 5B pencil for general tones and strong lines and shadows. I kept some parts of the paper white so that there was a good contrast between these and the very darkest parts. This kept the drawing lively and interesting.*

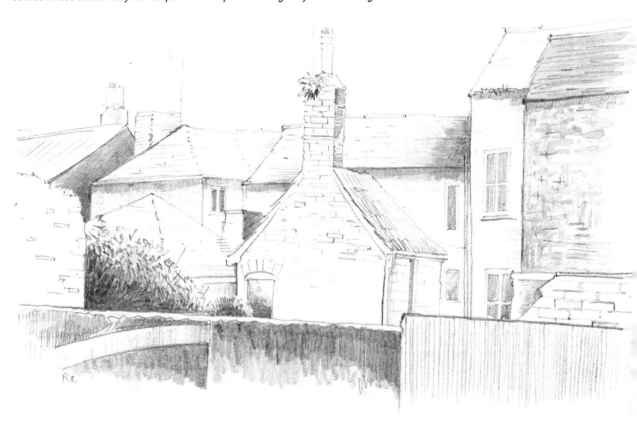

Charcoal

Drawing with charcoal has a long and interesting history. It was used by the Greeks and Romans, and was a favourite technique of Renaissance artists, particularly Titian and Tintoretto. This is a fine medium for large-scale drawings, sketching and preliminary studies. Additionally, charcoal is useful for making grey tones, subtle shading effects and accents of tone or texture when used in conjunction with other drawing media, including pencil and pastel. Charcoal is ideal for creating the illusion of three-dimensional form, as in life drawing, yet equally it suits loosely stated and freely expressed work – for example, when you are drawing a very atmospheric landscape.

Charcoal was one of the first materials used for drawings, and was originally made from burnt twigs cut from vines and willow trees. Today's compressed sticks of charcoal are produced by firing willow rods in a kiln until the wood has carbonized. You can buy boxes of stick charcoal of assorted thicknesses from very thin (3mm), up to thick (8mm). For large-scale work try scene-painters' charcoal, which can be up to 15mm thick. A few sticks of charcoal are always handy, either for sketching or for the quick addition of diffused general tones to drawings in other media. Another good way of working is to use stick charcoal for broad areas of tone, combining it with charcoal pencils for more precise lines, details and definition. The latter are available in soft, medium and hard qualities and, although still somewhat brittle, they can be sharpened to more of a point.

Initial work with charcoal may be disappointing because the tendency is to press too hard and therefore apply too much medium. However, a little practice soon shows what pressure is required and also what variety of marks and tones is possible. Charcoal is a sensitive medium, capable of delicate lines and very subtle chiaroscuro (light and shade) effects. Use it sparingly and try smudging it with your finger, a cotton bud or a small piece of cloth or paper to discover its blending qualities. General tones can be applied with a short length of charcoal used on its side. Charcoal dust can also be rubbed lightly into particular areas to create a slight tone.

All charcoal drawings should be sprayed with fixative as soon as they are finished.

Materials for Charcoal Drawing *Try using different widths of stick charcoal as well as charcoal pencils for finer work. Also shown here are a cotton bud and cotton wool for smudging and blending, as well as some fixative spray. The latter can either be applied with a simple diffuser or, more conveniently, by means of an ozone-friendly aerosol can.*

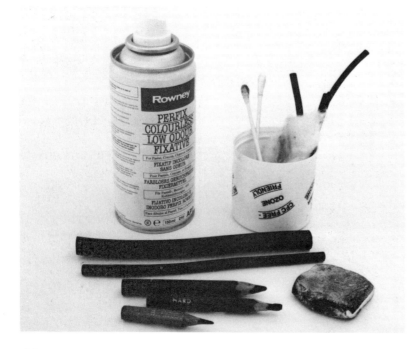

Test Strokes *Get the feel for charcoal by practising different strokes, tones and textures. Cartridge and pastel papers are fine, but try out some other types as well. Heavier quality papers will give broken lines and tones, as well as a more textural appearance to the drawing.*

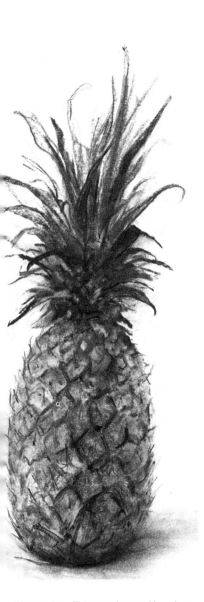

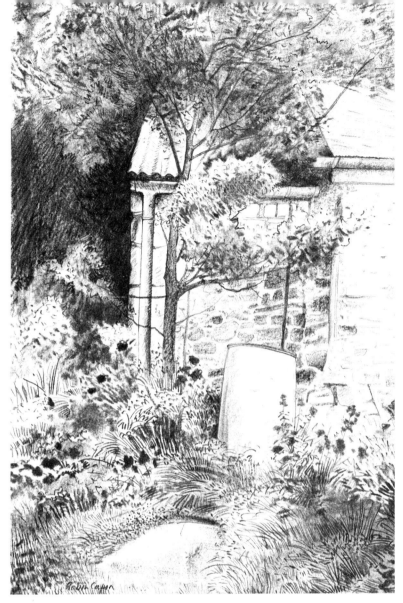

Pineapple *This was drawn with a short length of stick charcoal, the approach being tonal rather than linear. I started by blocking in the two main masses of tone: the top, leafy area; and the lower, fruit shape. These base tones were rubbed into the surface of the cartridge paper so that further tones could be superimposed where necessary, working from top to bottom. Finally, a few lines of detail were added to the fruit area and some highlights lifted out with a putty eraser.*

Toolshed *This subject required more specific lines and detail, so most of the drawing was made with a medium-quality charcoal pencil. Once the main background tones had been blocked in with stick charcoal, I worked over the whole drawing with the pencil, adopting various techniques to suit the different surfaces and effects required. For this sort of drawing the pencil will need sharpening frequently. Work from top to bottom in order to prevent undue smudging.*

Creating Highlights

Because it is a very soft, dusty medium, charcoal is easily removed from the paper with a putty eraser, or by using a small piece of Blu-Tack or bread.

■ Highlights can be lifted out of general shaded areas in this way. They can be left as sharp accents of light or softened by blending the edges.

Pastels

You will soon discover that there are two very contrasting types of pastel: oil pastel and soft pastel. Oil pastel is good for direct, expressive work. The colour is generally bolder, it cannot be smudged and blended in the same way as soft pastel, and it does not require fixing.

Soft pastels are made from dry pigment mixed with a binder and extender. The binder is usually a natural gum, such as gum arabic. Two varieties are produced: round and square. The square pastels are firmer, making them suitable for detailed linear work as well as broad areas of colour. Pastel colour is opaque. Also available are coloured chalks, which respond in a similar way to pastels, and pastel pencils, which are useful for adding lines and details.

By working on A2 sheets of paper (or even larger), you will gain a feeling of the spontaneity and freely expressive nature of this medium. Pastel is also fine for composition roughs, preliminary studies, colour 'notes' and sketchbook work. Experiment with cartridge and pastel papers, and try out the different shading and intermixing techniques explained on these pages.

Completed drawings in soft pastel will need spraying with fixative (a sort of thin varnish) to prevent them smudging. You can buy fixative in ozone-friendly aerosol cans or as a liquid which you apply with a spray diffuser. Prop the drawing up and spray it from a distance of about 25cm (10in), working systematically across it from top to bottom and taking care not to 'flood' delicate work. Always take proper precautions when using fixative: use it only in a well-ventilated room, or preferably outside.

Blending (1) *Try a few preliminary experiments on white cartridge paper as well as the more textured and coloured pastel papers, such as Ingres paper or Artemedia paper. Hold the pastel stick vertically, and then try using a short stick on its side. Vary the pressure. Here I have angled the pastel slightly so that one edge has more pressure than the other, thereby creating a dark to light blending effect.*

Materials and Equipment *Buy a small selection of individual pastels to begin with, some square and some round. A putty rubber is useful to reduce or lift colours, and a brush or sponge is required for dry tinting or working colour into the paper.*

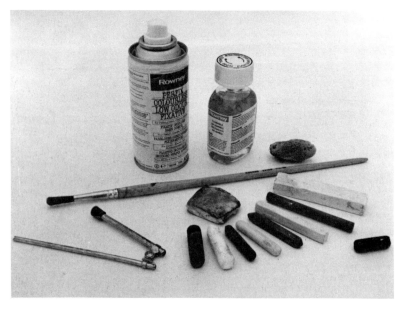

Blending (2) *Now try placing three bands of colour side by side, as in the upper part of this illustration. Blend these together by rubbing over them gently with your fingers, cotton wool, or a small piece of soft paper or cloth. Colour can also be blended or intermixed by working one colour over another.*

Old Barn *Pastel is excellent for this sort of quick sketch. Making a few drawings such as this one is a good way of finding out about the medium. Hold the pastel stick in different positions and try out a variety of linear and tonal effects. Use just a single colour to begin with so that you can concentrate on the essential characteristics and possibilities of pastel work.*

I used a square pastel for this drawing, the sharp corners creating the fine linear work and the full width of the pastel creating the more general shading and deeper tones.

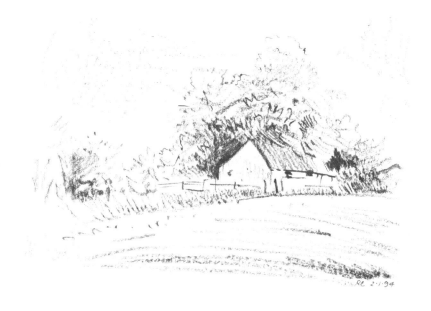

Coast Path *This drawing was made with a limited selection of colours on Winsor & Newton Artemedia pastel paper. The colour and texture of the paper chosen were important elements in the completed drawing. Various techniques were involved, including different shading and blending effects combined with line and hatching methods.*

Look also at the colour pastel drawings on pages 54 and 55.

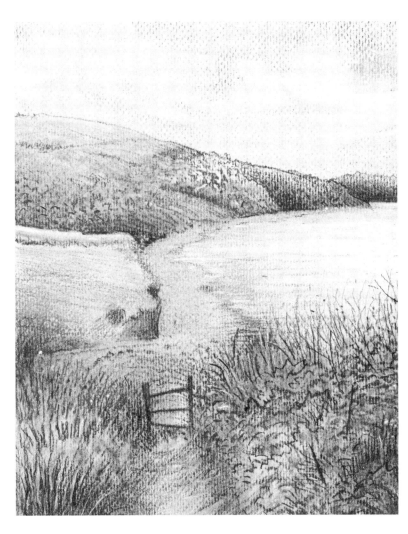

Pastel Papers

Pastel works best on paper which has a tooth or texture. This tooth or grain not only holds the pastel in place but also can be utilized as an effect within the drawing. Try the following papers:

- Bockingford 190gsm.
- Ingres paper.
- Artemedia papers.
- Canson Mi-Teintes.
- Saunders Waterford paper, Not.
- Cartridge paper 190gsm.

Crayons

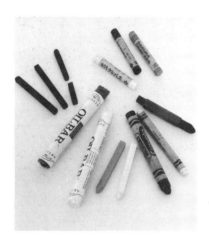

Crayons *A variety of different crayons is shown here. Working clockwise from centre top: an oil crayon used with a plastic holder; wax crayons; Oilbar crayons; sticks of Conté; and oil pastels.*

Various types of crayon are available, each with its own distinctive properties and potential. Wax crayons, Conté crayons, oil crayons and oil pastels are the main types, these being sold under a range of brand names.

It is perhaps because we all associate crayons with childhood drawings that we tend to dismiss them as unsuitable for more sophisticated work. In fact, they do offer a lot of scope for drawing and sketching, as well as for various texture, resist, sgraffito and etching techniques. A box of wax crayons is inexpensive and makes an interesting addition to an artist's range of drawing materials. Coloured crayons are rather crude for direct colour drawings, but I find black and white wax crayons very useful. It is possible to make quite sensitive drawings with a single, sharpened black wax crayon; this is also fine for adding tone and texture to a mixed-media drawing as well

as giving exciting effects when used as resist shading under a wash.

Leonardo da Vinci was probably the first artist to use sanguine crayon, which is made from iron oxide and chalk. Today's equivalent is Conté crayon, still available in sanguine (light red), as well as black, white and dark sienna. Conté is a square-section, hard, grease-free drawing chalk which doesn't smudge easily and which is capable of a range of effects, from fine, sensitive lines to deep, dramatic tones.

Oil crayons and oil pastels can be used in more or less the same way, the main difference being that oil crayons are harder and consequently not as flexible in their handling qualities. With oil pastels it is easier to work one colour over another. Oil crayons are made from pigment bound in wax, whereas the more recent oil pastels consist of pigment bound in oil. Both sorts of crayon are good for vigorous drawing in bold colour, and both are opaque, difficult to erase, able to be smudged with fingers, and soluble in turpentine.

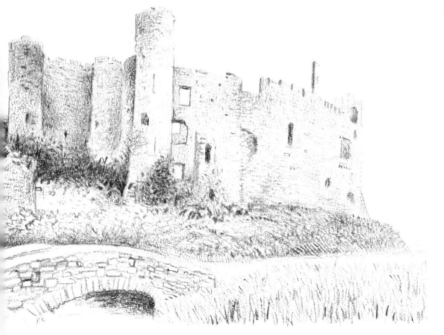

Laugharne Castle *This was drawn with a black oil crayon on 190gsm Bockingford mould-made drawing paper. The choice of paper was deliberate as its graining brings out the stonework texture of the castle walls. The edge of a square-section crayon was used to give really sharp, fine lines, as in the grassy foreground. Other parts could be shaded in quite solidly, although rich, dark tones are difficult to achieve with this medium.*

Crayons

Exmoor Landscape – Wax Etching

This is a fun technique, yet one with very striking graphic possibilities. Our normal method of drawing is to make dark marks on white paper, but in this case, of course, a 'negative' result is achieved, with white lines against a dark background. Work on a small sheet of heavy-quality cartridge paper. For a black and white result, as shown here, you will need a thick white wax crayon, Indian ink, a brush, and a fine needle, pin, or similar pointed instrument.

■ First cover the whole sheet of paper with a generous coating of wax. Hold the white wax crayon in a fairly vertical position and press hard as you shade across the paper. Check that no paper gaps show through. If necessary, shade in the opposite direction to ensure a complete and even layer.

■ Now paint over the wax with a coating of undiluted Indian ink. This will prove difficult to apply in one go because the wax will resist it. Keep brushing until the surface is covered and then leave the prepared paper to dry out thoroughly.

■ To make the drawing, use the needle or pin to scratch through the ink, thus revealing the white surface beneath. Various point, line and hatched effects are possible. Subtle tones are achieved by using a series of lines which only just show some white; for more intense tones you need to scratch right into the wax. As you can see, the drawing is essentially linear. Similar results are possible in colour, using a range of coloured wax crayons instead of white.

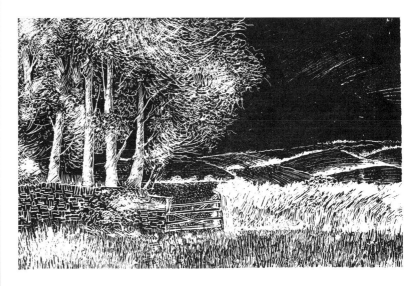

Exmoor landscape *Wax etching.*

Houses and Lane *Here a mixed-media approach was adopted, a number of different types of crayon being used on heavy quality cartridge paper. The foundation drawing was done with a black Conté pencil, this also being used to accentuate some of the straight edges and to draw in the fine lines. Oil crayon was used for the roofs and to shade the foreground areas, with Conté crayon for the walls and foliage, and oil pastel to enrich the deep, dark tones. Combining various media has enabled a range of tones and textures to be achieved, with a much livelier result.*

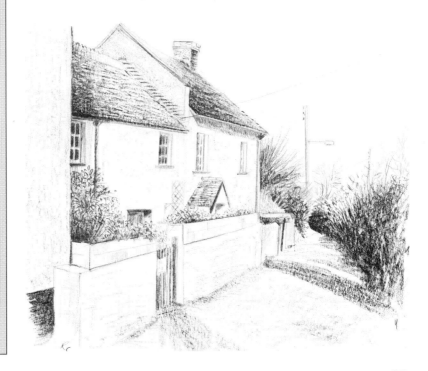

Unconventional Tools and Techniques

A drawing tool can be anything which produces a mark; it need not necessarily be something that was designed with the purpose of drawing in mind. So, as well as the more traditional shop-bought implements, there are any number of unconventional ones, either found or home-made, that can be pressed into useful service. Depending on the media you enjoy using most and the way you work, gradually you may find that one or two unorthodox tools are helpful and give some unusual and exciting effects.

A glance back through history or a look at the art of other peoples and civilizations shows that drawings can be made in an infinite variety of ways. Man has always had the urge to draw and has made use of those materials readily available in order to fulfil this desire. Drawings have been cut into rock faces with sharp stones, scratched into sand with a stick, carved on to animal tusks with a knife, made with a quill dipped in natural dye or ink, and so on. One fact is illustrated quite clearly: there is no set way to draw.

Drawing is a means of expression and communication, and whether it involves the sophisticated chiaroscuro effects of Leonardo or consists of just a few lines engraved into a piece of bark, it can be equally moving and effective. So, don't be afraid to experiment, to try out new techniques and approaches, and to use whatever drawing tools and materials help to achieve the impact you desire. You may discover interesting effects by scratching into dry medium with a nail or a similar sharp point, or applying wet-medium textures with a cork or comb. Try out some of the ideas suggested on these pages.

Comb *Use part of an old comb which has been dipped into some ink to produce the sort of effect shown here. Pour the ink into a shallow container so that it just covers the surface. Hold the comb vertically and dip the tips of the teeth into the ink. Now drag the comb across the paper to offset a series of lines. You can create wavy lines by moving the comb up and down, or a hatched textural effect by superimposing one set of straight lines over another.*

Other items such as sticks, pieces of card and corks can similarly be dipped in ink or paint to create offset lines and textures. These effects can be incorporated into ink drawings or mixed-media work.

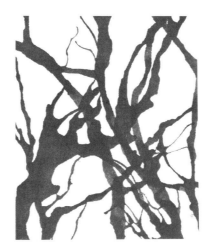

Blown Ink *Drop a few spots of ink on to the drawing paper and blow them around using a drinking straw. Place one end of the drinking straw just above the spot of ink and blow through the other end!*

This is another effect that can be used in an ink drawing for texture or for suggesting vague forms, especially if the ink is diluted. Alternatively, it is a technique that can be used as a starting point for a drawing, with the blown lines suggesting ideas and shapes which can be developed with further pen and ink work.

Impressed Lines *Draw on a sheet of paper with a spent ball-point pen so that the lines impress into the surface although they are not immediately visible. Now shade over the whole area quite heavily with a very soft pencil. The drawing should 'appear' as white lines against a dark background.*

As well as being an interesting technique in its own right, this effect is useful in heavily shaded or well-resolved pencil drawings to create light 'accents' or to bring out particular detail.

Unconventional Tools *Here are some less obvious drawing tools which are used for the techniques shown on these pages and in other parts of this book. The comb, cork, piece of card and sticks are all dipped into ink or paint to create lines and textures. The diffuser is used for spray effects and, similarly, the toothbrush is used for spattering. The candle is used in wax resist and wax etchings, the sponge for textures, the drinking straw for blown ink and offset texture, and the nails for scratching into ink, wax or similar media.*

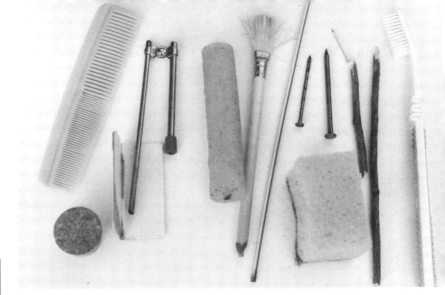

Marbling

Marbled paper makes a very interesting background effect over which to develop a drawing. There are various methods; one I have found to be inexpensive, simple and successful uses drawing inks with wallpaper paste. Follow this procedure:

■ Fill the plastic tray with water to a depth of about 5cm (2in).
■ Add a sparse sprinkling of wallpaper paste granules and stir into the water until dissolved. The wallpaper paste is added in order to make the water less fluid and to help the ink float on its surface. A little experimenting will indicate the right amount of paste to use – the water should be sticky rather than thick!
■ Drop a few blobs of ink on to the water's surface. Let the blobs splay out, or tilt the tray or use the wooden end of a paintbrush or a stick to swirl them across the surface. Do this quickly. For the landscape drawing shown on this page I used Indian ink in this way. Obviously, a variety of colour effects can be achieved using different coloured inks.
■ Lay a sheet of cartridge paper gently across the surface of the water and immediately lift it off. Handle it carefully and place it flat to dry.

Materials for Marbling

■ Plastic tray (approximately 25 x 40 x 10cm, or 10 x 16 x 4in).
■ Wallpaper paste.
■ Water.
■ No. 6 stiff-haired brush or stick.
■ Indian ink or coloured drawing inks.
■ Cartridge paper.

Landscape *This drawing was made on marbled paper prepared in the manner described in the panel. The results of marbling are, of course, completely unpredictable, so it is best to produce a whole batch of papers in this way whilst the equipment is set up, and then to select one which suits the subject and effects you require.*

Here, a marbled paper was chosen to suggest a cloudy sky. In the lower half of the drawing the landscape was added in pen and ink and pencil over the marbled effect.

25

EXPLORING BASIC TECHNIQUES

The term 'technique' refers to the use of a particular medium or drawing implement, just as it does to the way you apply or control certain elements in your drawings, such as line or tone. Thus, pen and ink is a technique and so is wash or using texture. Now that you have gained some knowledge and confidence with the main drawing media described in the previous section (pages 12–25), you can move on to explore the specific techniques of line, point, tone, texture, wash and mixed media explained in the next sequence of pages.

These techniques are appropriate to the whole range of media, so test them out with as many different types as possible and on a variety of papers. Experimenting in this way will give you a wide experience of the contrasting effects you can use in your drawings to create the sort of impact and interpretation you want.

Line

Line is the fundamental technique for establishing general shapes and areas in a drawing. Often, these basic shapes are enhanced with more specific outlines, contours or linear details, and perhaps with the use of tone and additional techniques, although a drawing can consist entirely of lines.

Pens, pencils and most other drawing tools and media are designed to make lines. The sort of line you make is dependent on three main factors: the limitations and characteristics of the medium; the type of paper or other support/surface being used; and how hard you press. Indeed, the last two factors are very important in contributing to the particular quality of line you require in your drawing.

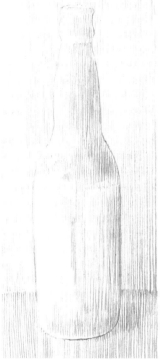

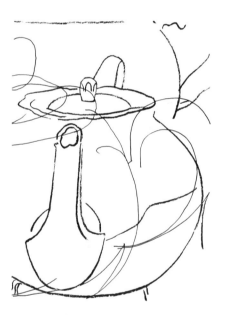

Lines *Using cartridge paper and a heavier quality paper, try some exercises such as this to test out different media and the sort of lines they can produce. Here, starting at the top, I used a mapping pen, a fibre-tip pen, a pencil, a charcoal pencil and stick charcoal. Obviously, whilst the thickness of the individual drawing tool is the main influence in determining the width of the lines produced, pressure is also important. Heavy pressure will tend to give wide, solid, bold lines while light pressure will give thinner, broken, sensitive lines.*

Bottle *In addition to showing the shape of something, you can use lines in such a way that you create a sense of tone and, consequently, form. Using a 4B pencil I varied the pressure and spacing of lines here to make contrasts between faint and bold and light and dark. In this way I could show not only the shape of the bottle but also suggest its three-dimensional quality.*

Teapot *Single lines can also imply depth and form. In a contour drawing such as this, you can vary the thickness of the line as well as its strength (light/dark value) to help achieve the impression of something three-dimensional. Dark lines stand out and appear nearer, whilst fainter lines are less obvious and look more distant.*

Line

Thatched Cottage *I made this drawing with a mapping pen dipped in Indian ink. Notice how I made the lines follow the direction or surface characteristics of each part of the drawing. I used heavier hatched lines closer together to emphasize the nearer end of the thatched roof, and the intense shadow on the underside of the thatch was made with a cross-hatching technique. The long hatched lines in the foreground are set at an angle and were made with increasing pressure towards the lower edge of the drawing, thus suggesting a sense of recession and depth.*

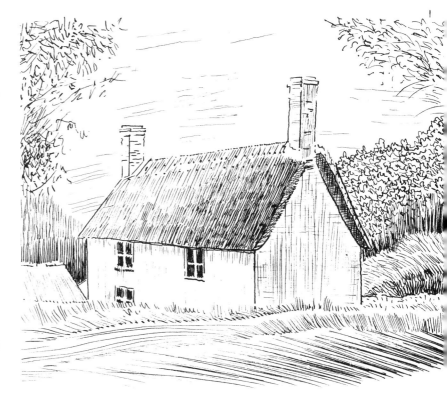

Fish *This drawing was also made with a mapping pen and exploits a wider range of line techniques, from very delicate straight lines to bolder flowing lines and intense hatched shading.*

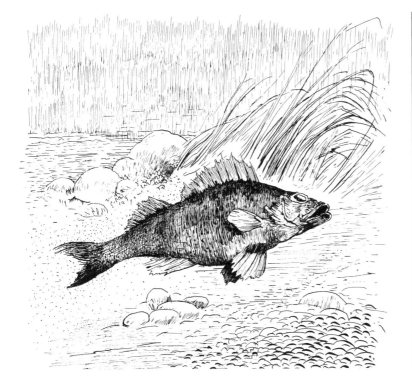

Choosing Lines

■ Where you have a subject which is going to work best as a line-drawing, consider the sort of effects you want and the best medium(media)/implement(s) and type of paper to realize these.

■ Remember to use variations of pressure to make lines of differing strength and intensity.

■ Wavy lines will suggest movement, negative lines (white against black) will create contrast, and lines of different thickness and spacing will imply depth.

■ Linear techniques are good for sketchbook work, preliminary studies and composition roughs.

Line

Towpath – Step-by-Step (1–3)

Step 1 *The first task is to fix the main shapes in the general composition of the drawing. Contrary to all the usual extolled principles of composition, I decided to place the large tree quite obviously centrally. However, the strong upright line of the tree will be countered by the diagonals of the foreground area and a zigzag movement into the distance.*

My initial lines were made directly with a fine mapping pen. If you lack the confidence to work straight off with pen and ink, then make your foundation drawing in pencil. Use very faint pencil lines which will easily be covered by subsequent pen lines or which can be erased when the final drawing is dry. Don't go into any detail at this stage, but instead consider the overall arrangement of the idea.

Step 2 *Next, I like to make quite positive decisions about the composition, so I work a little further on the general shapes and resolve them to my satisfaction. This gives a good structure to the drawing – an essential ingredient if the finished result is to work effectively. No matter how skilled the pen and ink techniques, there is little way of disguising a weak skeletal drawing.*

Each of these main areas must now be considered as far as tone and technique are concerned. What sort of pen lines will best convey the characteristics or qualities of each area, and how does each relate in terms of tone to the rest? It is best not to get anything too dark at this stage, but rather to underplay the tones. Working like this, I developed each area in a general way, providing a basis for further enhancement and detail.

Step 3 *Working from distance to foreground, I now consider each area in turn, bearing in mind the overall balance and contrasts of tone and effects I want to achieve. All the preceding lines were made with a Gillott drawing pen, consisting of a wooden penholder and a fine nib. Whilst further work will be done with this pen, some of the bolder lines and deeper tones in the ivy of the tree, around the banks of the river and in the foreground will be made with a mapping pen which has a slightly broader nib.*

I find it best to work systematically from the faint tones and general shapes of the distance to the more intense lines and detail at the front. You will see that I left much of the background as it was, concentrating instead on developing the tree and most of the foreground area.

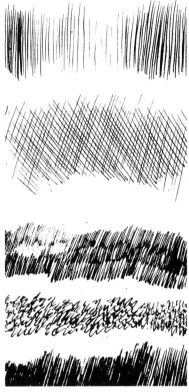

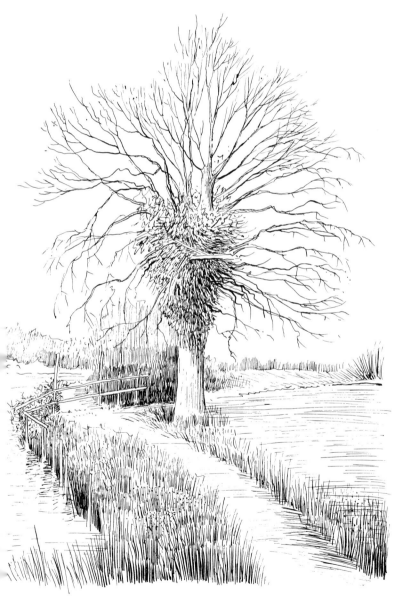

Pen Lines *If you are not familiar with the likely response and possibilities of a particular drawing tool or medium, then it is always a good idea to see what sort of lines and effects it will make.*

These lines were made with a mapping pen and Indian ink. Here I tried out some of the techniques I envisaged using in the main step-by-step drawing. Working down from the top are: straight lines used with different spacing and intensity; a cross-hatching technique; a short-stroke, quick-shading method; short, curved strokes (as in the ivy); and an angled, bold, linear-shading effect.

Try pulling the pen towards you in flowing strokes to create lines, as well as pushing it away from you. Use it lightly at a very shallow angle to make soft, weak lines, and hold it vertically and press harder for bold lines. Dip-pens can blotch quite easily, so know what the pen will do before you ask too much of it!

Point

This technique uses contrasts and variations of light and dark areas to suggest the shape and form of things. It is therefore a question of seeing and interpreting tone rather than hoping to make accurate outlines or involve specific detail.

Pens are best for this technique, and in particular fine, fibre-tip pens, ball-point pens, art pens and technical pens that use interchangeable nibs of various thicknesses. Soft pencils also work quite well, and, it is possible to combine different drawing tools to create a variety of tones and effects.

Choose a type of paper compatible with the medium being used. A smooth-quality, white cartridge paper is suitable for most work, although white card or layout paper is sometimes preferable for drawings made with technical pens such as the Rotring Rapidoliner. If there is any doubt, test out the drawing tool on a small scrap of paper. You may find that some papers are too absorbent and therefore create a slightly blurred impression, whilst others are too smooth and cause the pen to skid.

Making Point *The drawing instrument or medium you use will determine the size and quality of the point or dot produced. Try a little experiment such as this, in which, from the top, I used a fine technical pen, a fine fibre-tip pen, a pencil, a ball-point pen, a felt-tip pen, charcoal, a drinking straw dipped in ink, and the end of a pencil dipped in ink. Practise holding the instrument vertically and use a quick, gentle stabbing motion to create the dots.*

Group of Trees – Step-by-Step (1–3)

Point is ideal for subjects (such as this group of trees) which rely on showing mass and tone rather than lots of detail.

Step 1 *I started by faintly dotting in the horizon and the relative shapes and positions of the tree trunks. This created a good basic structure for the drawing, and from there I was able to decide where other necessary dotted lines should be placed so as to divide the whole drawing into a series of main shapes to develop.*

The initial work was made with a fineline fibre-tip pen. The odd dot in the wrong place doesn't matter, but because ink is being used, it isn't possible to erase any of the marks. An alternative way of working is to start with a faint pencil drawing to ensure that the main shapes are in the right place before beginning in ink. Any surplus pencil lines can be erased later. Block in the main shapes with a sequence of dots and start to think, see and interpret in terms of light and dark.

Step 2 *Deal with the light areas first, taking care not to overwork them. Work up the entire drawing at the same pace rather than concentrating on one area at a time.*

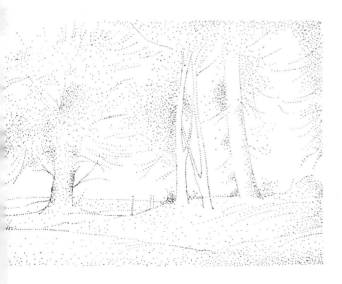

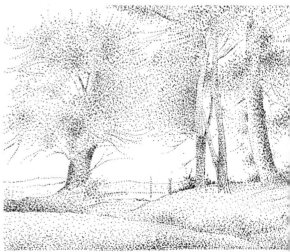

Point

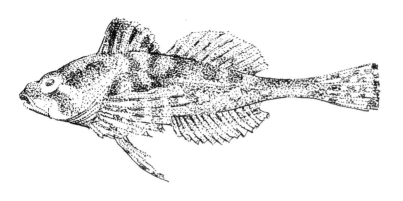

Fish *This was drawn with a fineline fibre-tip pen. I used one or two actual lines to define the main shape, but most of the work was in point. Patches of intense dots contrasting with more open areas proved a good way of suggesting the markings on the fish as well as its three-dimensional form. Pressure is also a factor in achieving subtle or bold dots.*

Step 3 *Strong contrasts are essential if the drawing is to read successfully and have some impact. For the really dark areas I used a fine felt-tip pen, a more deliberate dotting action, and firmer pressure. I try not to get involved in one area, rather working across the whole drawing and then repeating this process until I am satisfied with the way everything looks. It is often necessary to exaggerate tonal contrasts to achieve a good result.*

MATERIALS
For Step-by-Step

- ■ Fineline fibre-tip pen.
- ■ Fine felt-tip pen.
- ■ Cartridge paper taped or fixed to a board.

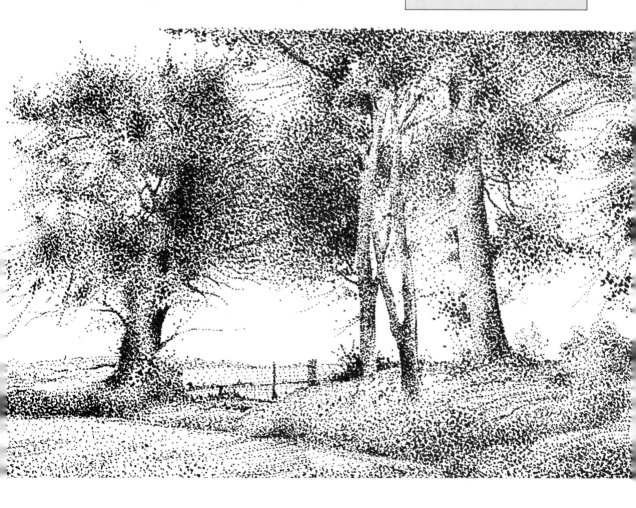

Tone

One of the main problems in drawing is how to make things look three-dimensional. When we draw, we work on flat sheets of paper and usually our aim is to draw objectively and representationally so as to convey a good likeness of something. We are, in effect, trying to describe things which are three-dimensional in a two-dimensional way. In order to convey an illusion of space and depth we therefore need to involve devices such as tone and perspective.

Tone, which is the use of light and dark in a drawing, will help to give the impression of substance and form, and of space and distance. You will already have noticed how contrasts of light and dark work in this way in many of the drawings on the previous pages. To understand tone you must get used to looking at the way light plays on different objects – in other words, how some parts appear in strong shadow while others are in highlight. Notice how this distribution of light and dark helps to describe the form and make it look square, spherical and so on.

You will need to develop a variety of shading techniques so that you can give a range of tonal effects from light to dark in your drawings. Once again, the possible effects are influenced by the medium being used and perhaps also the type of paper. Avoid overshading. In general, use the white of the paper as the lightest tone and try to achieve some good contrasts between this and the darkest areas. Look at the subject with half-closed eyes to help you eliminate unnecessary tones and to see where there are contrasts.

Shading Techniques *Use some sheets of cheap cartridge paper to try out these techniques with different media – soft pencils, charcoal, pen and ink, pastel and so on.*

Line *Line shading can be used in whatever direction suits the subject you are drawing. Try some lines such as these, at an angle of roughly 45°, working in a sequence across the paper. Vary the pressure and spacing to create light and dark patches.*

Cross-Hatching *Lines in one direction are covered with lines worked at right angles. This gives a more solid and intense tone, although again the spacing and pressure of the strokes will determine the strength of the shading.*

Scribbled *Make this effect using a quick, circular movement of the drawing medium, working over some areas to make the tone darker.*

Pressure *Using a very soft pencil or similar soft medium (such as chalk, charcoal or pastel), start with heavy pressure and gradually ease up so that the tone progresses from dark to light with no obvious interruptions.*

Blended *Apply the basic tone in the same way as the previous method (pressure), but then use a small scrap of paper to rub over and into it to create a more subtle, blended tone.*

Eraser *Create highlights and lighter patches by 'lifting' with a putty or kneadable eraser.*

EXERCISE

Draw several simple objects (like those on the opposite page) to look as three-dimensional as possible, using the shading techniques and media that seem most appropriate. Try to match the technique not just to the range of tones but to the surface characteristics of the object.

Tennis Ball – Step-by-Step (1–3)

Step 1 Draw in the outline of the object and think about the main areas of tone. As the shape is theoretically circular, use a pair of compasses to draw a faint outline if you wish, then go over this with a free-hand line. Soften the outline where there is a highlight.

Step 2 Look closely at the outline and modify it, as necessary, with variations to its strength; likewise, finalize the lines of the stitching. Begin to build up the tone. I used a soft (4B) pencil for this.

Step 3 Notice where the very darkest tones are – in this case at the base of the sphere – and work these up to the right strength. Keep a good contrast between the highlight and the dark shadow. Try to capture the hairy surface quality of the object as well as the distribution of tone.

Box – Step-by-Step (1–3)

Step 1 Concentrate first on a convincing outline. With this sort of shape set at an angle to you, perspective will play its part (see pages 65–7 if you need help with this). Notice how the nearer edges are emphasized and the distant ones are fainter.

Step 2 I used a 4B pencil here, but with little pressure. Apply a general tone to those areas in shadow. Try not to make the shading too grained, especially if you are using a harder pencil; such lines may be difficult to disguise later.

Step 3 Work from the lightest areas at the back to the very dark shadows at the front. Exaggerate the tones slightly if necessary so that there is adequate contrast. I used the blended shading technique shown on the opposite page to convey the smooth surface of this object as well as its tonal qualities. Where needed, use a putty rubber to soften edges and tones.

Using Tone

When you are drawing something from direct observation, get used to noticing the source and direction of light. Examine how and where this creates shadows. Whether you are drawing a landscape, portrait or still life, understanding the effect of light is always important, for light and dark are not only essential for conveying a sense of realism, space and form, they can add atmosphere, feeling and interest to the picture.

The choice of medium should be considered carefully in respect of the tonal qualities you require. In general, the 'softer' media – such as pencil, chalk, charcoal and crayon – will offer the greatest scope. These media will respond well to variations of pressure and can be modified by using blending, offsetting, erasure and other methods.

Horse *Woodcuts and many forms of graphic art use the simplest form of tone – black and white. This is not as easy as it sounds, for getting the right balance between the positive and negative areas, and in such a way that they suggest a sense of form and dimension, can prove difficult.*

As with any tone technique, however, it is a question of seeing how the light and dark areas distribute themselves across the subject and what they do to tell you about its form. With this technique, the highlights and near-highlight areas are regarded as one tone (negative) and the rest as a second tone (positive). The boundaries between these tones are clearly defined rather than blended or diffused, as they might be with other shading techniques. Try drawing a single object (such as a cup), which has been placed in a strong light, using this positive/negative type of shading.

Exercise

As a good introduction to tone it helps to think in terms of three basic values: light, medium and dark. Try a design like the bottles in the adjacent illustration.

Make a template by cutting the shape from folded thin card or paper. Draw around this in various ways, as I have done, and shade in each separate shape with a different tone to those next to it. Use a sharp, soft (6B) pencil.

Woodland Path *This drawing was made with charcoal and charcoal pencil. For drawings where you want to combine general areas of tone with some sharper, more defined lines and accents, these media prove an excellent combination. Another advantage of charcoal is that tone can be applied quite rapidly, and then lifted and blended to achieve a variety of effects. This is a splendid medium for jotting down a lot of information quite quickly, as in sketchbook and landscape drawings.*

Note the variety of effects in this drawing. The stick charcoal was used in different ways to create diffused tone, more intense darks and stabs of tone, with the sharpened charcoal pencil used for outlines, hatched shading and bold accents of tone.

Skull –
Step-by-Step (1–2)

Step 1 Using a charcoal pencil, I sketched in the general shape of the skull lightly, accentuating the outline where necessary and indicating where the deep tones would occur. Work with faint lines at this stage, as these can be lifted with a putty eraser if they are wrong; heavy lines are more difficult to erase.

Step 2 All the main tones have been worked in with stick charcoal, smudged with a finger where a fading or blending effect was required. I kept the white of the paper for the lightest areas. Having shaded the general form in this way to my satisfaction, I then worked into the charcoal with a charcoal pencil to add detail, intensifying some of the darker areas and re-establishing any lost outlines.

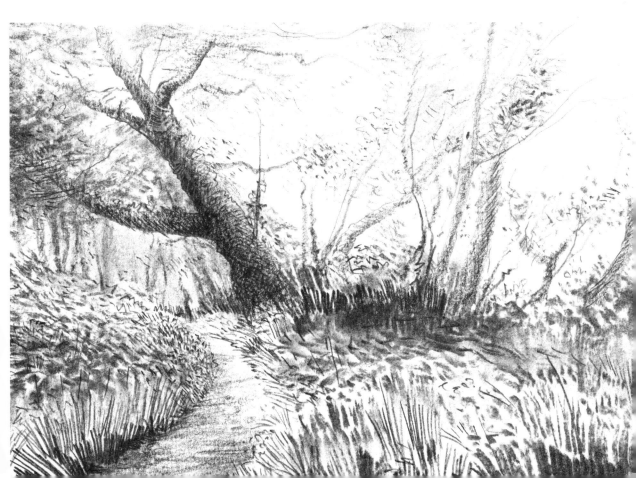

Using Tone

In order to create a real likeness of something, we need to consider both shape and tone. These two qualities work together to describe the subject and give it form and substance. Often, the shape is confused by the great range of light, textures and details which adorn it. Our first task, therefore, is to learn to identify the essential shapes. Once these are drawn in we can move on to tackle the modelling and detail.

Look at the step-by-step drawings shown here and notice how working through a number of stages helps you to evolve an accurate result using tone.

Still Life – Step-by-Step (1–3)

Exercise

To help you appreciate the different values of tone in a drawing it is a good idea to make a tonal strip like the one illustrated below. This can be kept in your sketchbook or with your drawing equipment as an aid to assessing the range of tones needed for a particular subject.

Copy the measurements of the strip below. You can increase the range of tones by adding one or two more divisions if you wish. Shade from light to dark. I used a B pencil for the lighter range and a 4B pencil for the darker, although obviously pressure plays its part in achieving the correct tone. Make each division slightly darker than the preceding one.

Step 1 *A simple still life, such as the one demonstrated here, provides good practice for using tone and understanding how to suggest the form of objects and the space around them. Choose three or four objects which contrast in shape and surface characteristics. Although two objects here were made of glass, the bottle was of a dark glass that was much less transparent than the vase in front. Arrange the objects in an interesting way and in a light which creates good highlights and obvious shadows.*

Notice the positions and proportions of the objects in relation to each other. Start by constructing their accurate shapes, using whatever guide-lines you feel are necessary. Satisfy yourself that these shapes are sound before going any further. However good the shading, it cannot compensate for poorly drawn

objects! Half-close your eyes and make a thorough assessment of the range of tones. What is the strength of the deepest tone in relation to the rest?

Step 2 *Use a soft pencil to get the feel of the overall distribution of tonal values. Avoid pressing or shading too heavily at this stage. The initial outline drawing was made with a B pencil, a 4B then being used to block in the main tones loosely.*

Check constantly what you are drawing against the objects in front of you. Avoid getting involved with any one area to the exclusion of others, and evaluate each tone as a relative value to those around it as well as to the whole drawing. Use the pencil at a shallow angle, holding it about half-way up – in this way the marks will be free and not too heavy, and you will be able to cover quite large areas quickly with some shading.

MATERIALS
For Step-by-Step

■ B pencil.
■ 4B pencil.
■ Wedge-shaped eraser.
■ Putty eraser.
■ Cotton bud or small piece of paper for blending.
■ Cartridge paper.

Step 3 *Taking some time and trouble over the previous two stages allows you to make an accurate foundation drawing so that you can then move on with confidence to develop each object in detail.*

I started with the background tone, adding a little more to this with the B pencil and then blending the shading behind the main objects. Next, I worked on the bottle. The cap, labels and some of the shading on the left-hand side were done with the B pencil, whilst for the rest I used the 4B. One or two parts of the bottle had almost the darkest tones in the whole arrangement, so I could register these quite boldly. The smaller highlights were ignored at this stage, and I concentrated instead on the mix of actual tone and reflected tone. Where necessary, the shading was blended using a small scrap of paper. Finally, the various highlights were lifted out by just dabbing the surface with the corner of a putty eraser. This method can also be used for softening some of the tonal areas, while the wedge-shaped eraser should be used for more obviously defined highlight areas.

I worked at the other objects in the same way, bearing in mind their different surface qualities, and aiming to relate their treatment and tonal effects to the drawing as a whole.

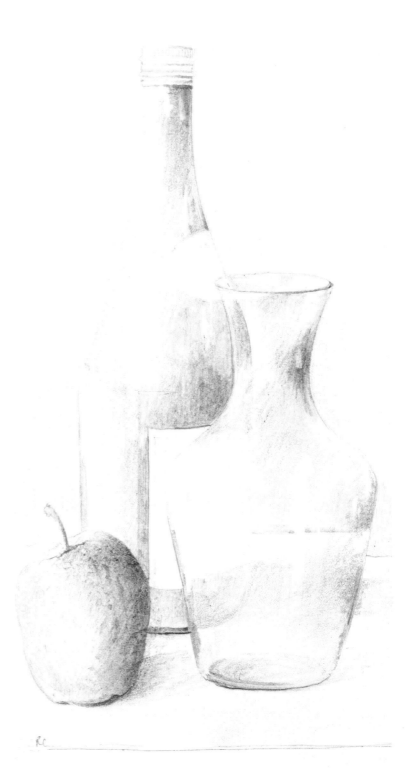

Texture

You will come across many subjects that you wish to draw which have a distinctive surface quality or texture, and which set you the problem of how to convey such an effect in your drawing. Because of the media and methods used, drawings cannot achieve the same tactile qualities which can be found in many paintings or, more obviously, in sculpture. Therefore, in drawing we have to give an impression of textures rather than actually creating them.

There are various ways of suggesting texture. You can use a repetitive technique, such as hatching or dotting with a pen, or you can involve other, perhaps more unusual methods such as frottage, stippling and spraying. Experience of and experimentation with all of these methods will help you choose how best to interpret a particular surface. But whichever technique you choose, you must be sure that it fits in with the rest of the drawing and

that it suits the type of paper being used. Working on heavy quality water-colour paper with pastel or charcoal, for example, is a good way to create an overall feeling of texture. This will give broken tones and mottled effects, but solid, smooth tones will be difficult to make. Often a compromise must be sought with the type of paper you use and the range of techniques you can employ. If you have any doubts about the suitability of the paper you intend using for the proposed mixture of techniques, do a small test exercise first.

MATERIALS
For Step-by-Step

- ■ B drawing pencil.
- ■ 4B drawing pencil.
- ■ Charcoal stick.
- ■ Charcoal pencil.
- ■ Wax candle or white wax crayon.
- ■ Ink wash.
- ■ Cartridge paper.
- ■ Hardboard texture.

Church – Step-by-Step (1–2)

Step 1 *After the main outlines were drawn in, wax was applied to the whole of the wall on the right-hand side, then wash. The texture in the foreground was made by placing a small piece of hardboard under the drawing and shading over that area with a soft pencil. The general bush area (lower right) was sketched in with charcoal.*

Step 2 *Now, working from the back, I added more pencil shading and detail to the church and buildings at the side, including some dotted texture to the porch. A little detail was added over the wax and wash area, also in pencil, and the foreground tidied up, with more charcoal and charcoal-pencil work on the right-hand side.*

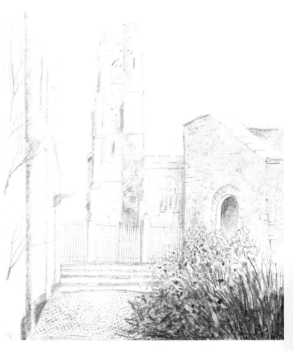

Making Textures

Test out for yourself a variety of different ways of making textures, such as the ones in the adjacent illustration. These are, from top left to bottom right:

■ Stipple. Use a stiff-haired brush dipped in a little ink and lightly stab up and down on the paper.
■ Sponge. Dip a fine-textured sponge in some ink or paint and offset on the paper.
■ Spattering. Use an old toothbrush dipped in ink and pull back the bristles to create a fine spray.
■ Dry brush. Drag a lightly laden stiff-haired brush over heavy quality paper.
■ Pencil and pen dotting.
■ Wax resist. Apply a wash over a waxed area.
■ Charcoal. Use it on its side.
■ Frottage or Rubbings.

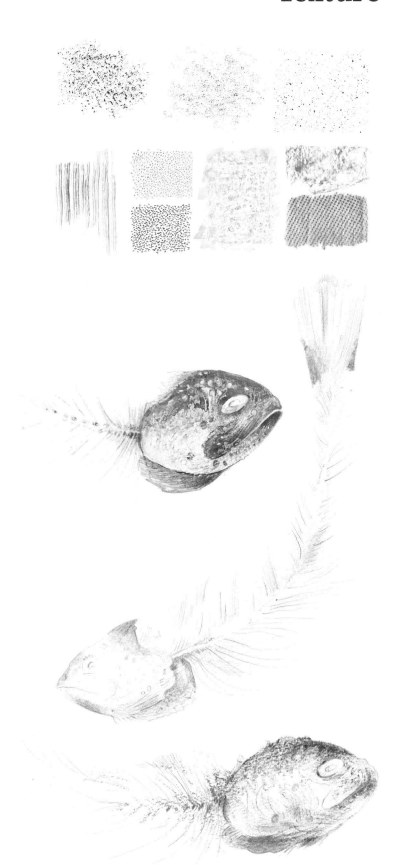

Fish Heads *This is a subject which I felt needed some textural effects to portray it convincingly. In each of the three studies I tried out a different technique. At the top, the head area was first coated with wax, using a white wax crayon. Over this I applied a weak wash of Indian ink, also using this on the skeletal part. When dry, the head was developed with further ink washes and some pencil lines.*

The fish in the centre was drawn with a pencil and wash technique, using a carpenters' pencil for some of the general tones. The study at the bottom was made in charcoal and charcoal pencil, also over a thin wash, but taking advantage of the texture of the paper.

WASH AND MIXED MEDIA

Wash is diluted ink or watercolour. It is mixed by putting a small amount of the ink or paint in a shallow container or palette and adding water. The more water you add, the weaker will be the tone of the wash. Experiment on some scrap paper first.

You can use wash to add tone to line-drawings made in ink or pencil, or you can work over basic areas of wash with pastel, charcoal pencil, ink, crayon – indeed, most drawing media. Work on stretched cartridge paper (*see* page 9) or use heavier, watercolour papers.

Iris – Step-by-Step (1–3)

Step 1 *This demonstration uses a combination of water-soluble and normal graphite pencils. Start by drawing the outline shape with a B pencil. Next, add the basic tones using a water-soluble black pencil. Shade lightly so that the tone rests on the surface of the paper and is not ingrained. Retain the white paper where you need highlights. Further shading can be added later, so be careful not to do too much at this stage.*

Trees *This was drawn with a mapping pen and very diluted washes of Indian ink. I started with a few simple outlines drawn with the pen, then I added the areas of wash using a no. 6 watercolour brush. Once the wash had dried, I could work over it where required with different pen lines to complete the rest of the drawing.*

Wash *Try mixing different strengths of wash and testing them out on several types of paper. This is not a fussy technique but one for adding general patches of tone, so always use the largest brush possible. Use a wide, flat, soft brush for applying large, even areas of wash quickly. A brush dipped in just a little medium which is then lightly dragged across the paper will give the sort of broken, dry brush effect shown above.*

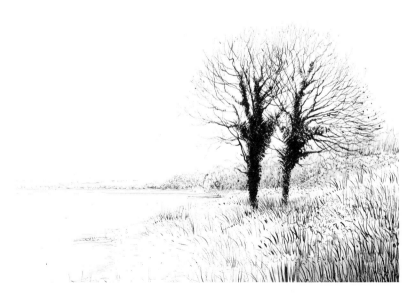

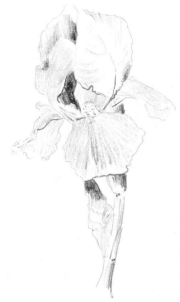

40

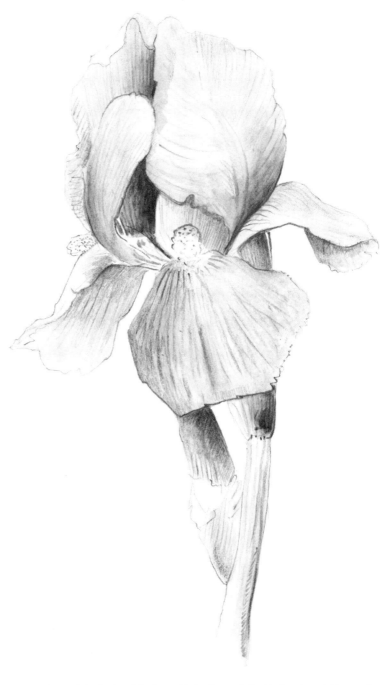

Step 2 *If you are not working on stretched paper or watercolour paper, then the surface is likely to buckle when wetted and possibly dry in a distorted state. Prevent this by taping the edges of your drawing to a board with masking tape or gummed brown-paper strips. With the no.6 watercolour brush dipped into some clean water, wet each part of the drawing. Load the brush quite generously and work from the top of the drawing downwards. Use a sort of pushing motion on the brush so that the dry pigment loosens and begins to diffuse. Manipulate the wet tone until it looks about right. If it seems too dark, dry the brush, place it over the offending area and lift off some of the surface liquid. You can also soak up or blot overwetted areas with a piece of tissue.*

Work across the whole drawing in this way. You are aiming for approximate tones and the general character of the subject; these can be enhanced with further pencil work when the wash areas have dried.

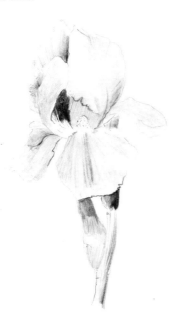

Step 3 *Most of the final work is done with the B pencil, the black water-soluble pencil being used only to enrich some of the very dark shadows. The outline can be strengthened where necessary, such as on some of the undersides of the petals, and more detail and veining given to these. The graphite pencil also works well for shading lightly over the wash areas where slightly stronger tones are needed. Use a putty eraser to clean up around the edges and reduce pencil tones which are too bold.*

Combining Media and Methods

Working with a single medium can sometimes be restricting, preventing you from expressing fully what you want to say about your subject. No matter how inspired you are or how original and exciting the idea, the success of the drawing will also depend on practical and technical issues, such as choosing the most suitable media and techniques.

You will find occasionally that, in order to create the right mood or to convey the special characteristics of a subject, you will need to combine several media and consequently extend the range of techniques, tonal values and surface effects you can use. Additionally, mixed-media effects will give

Thatched House – Step-by-Step (1–3)

Step 1 *This subject, with its thatch, foliage and variety of light and dark effects, seemed to invite a mixed-media approach.*

Having decided that it would work best tackled in this way, my next step was to give some thought as to which medium would be the most appropriate for each part of the drawing. I then tried to visualize the likely result. For any drawing it is worthwhile spending a few minutes looking and planning how you are going to develop it, but this is especially true where several media are involved. Think about the order in which you need to use the different media and plan out the stages of the drawing.

Perspective plays an important part in this composition, so it was essential to ensure that the various angles were correct and that a sense of distance was achieved. Therefore, my preliminary work was in pencil, easily erased and modified if required. To the basic outlines I added a suggestion of the general distribution of lights and darks, keeping to the B pencil at this stage.

Step 2 *As a mid-tone and general unifying background shading device, I decided to use a light wash. This also provides a good surface to work over in places with some of the other media, and will just tone down the paper sufficiently to create the right sort of contrast.*

The wash was made from heavily diluted Indian ink. It was mixed to a strength which gives just the merest tint on the paper and was applied quickly with a flat, half-inch, one-stroke watercolour brush. When the wash was dry I added some more lines and tones with pencil, this time using the 4B pencil.

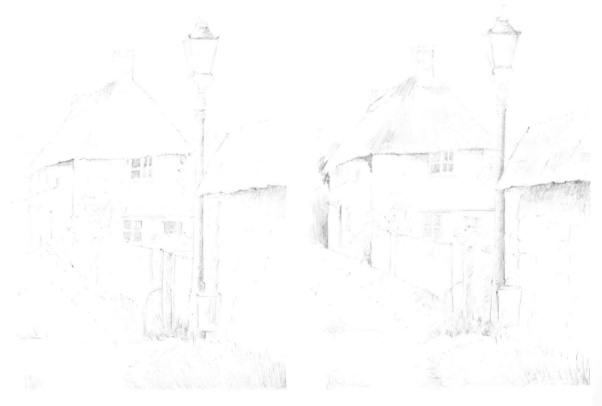

Combining Media and Methods

lively contrasts and add to the impact and interest of the drawing.

You could choose some media specifically because they allow you to draw in great detail, while others will give you the textures or tones you want, or add to the overall vitality and atmosphere of the drawing. However, you need to be sure that any combination of media will work well from the technical point of view as well as visually. Will the different media mix well together? Will you be able to work over one medium with another if you wish, or erase it? Will the media combine satisfactorily as far as the general tonal range is concerned? Check points such as these, and if you are unsure then make a few tests. Also, remember to check the suitability of the drawing paper for the mixture of media and techniques you intend using. Use stretched paper for any mixed-media work that involves wash and texture techniques.

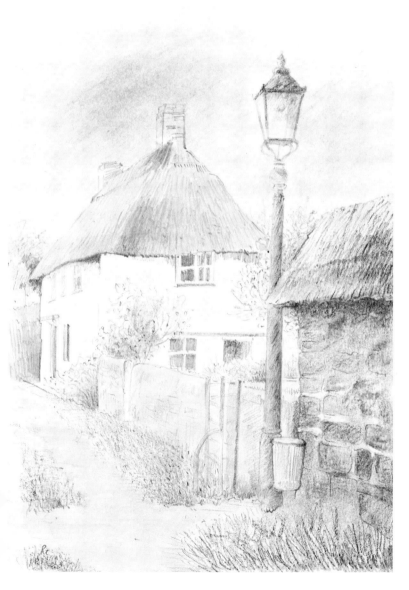

> ## MATERIALS
> ## For Step-by-Step
>
> - B drawing pencil.
> - 4B drawing pencil.
> - Indian ink wash.
> - Flat wash brush.
> - Charcoal.
> - Charcoal pencil.
> - Putty eraser.
> - 150gsm cartridge paper.

Step 3 *For the sky tone I used charcoal lightly dabbed in place with a piece of cotton wool. First, I shaded a scrap of paper heavily with charcoal, then I dipped the cotton wool into this before using it on the drawing. The light patches in the sky were taken out with a putty eraser.*

More pencil lines (6B) were added to the thatch, and used to develop the trees and shrubs, and to indicate some of the stonework on the wall. Most of the grass area either side of the path in the foreground was worked up in tone and detail using a Conté crayon. The wall and thatch on the right-hand side of the picture, as well as the deeper shadows on the lamppost, were strengthened with charcoal work and charcoal-pencil lines.

CREATING ACCURATE SHAPES

There are many philosophies, styles and approaches to drawing. Whilst drawing is fundamentally a means of communicating ideas about something to other people, there are many ways of doing this. Some artists work very freely and expressively, while others may choose an entirely abstract inter-pretation. For many of us, the aim in the majority of our drawings is for rep-resentation – that is, to show things exactly as we see them. And even when this approach is tinged with our personality, as indeed it should be, or some exaggerated viewpoint or expressive style, a knowledge of how to construct accurate shapes is always useful.

Devices such as 'boxing up' and the use of guide-lines (*see* pages 46–7) help us to evolve accurate shapes. It is helpful to know how to use these methods as a drawing aid, but do not let them inhibit a degree of freedom in your work.

Cup *For a shape like this, start with the basic cylinder and modify it accordingly. Assess the angle of the sloping sides from an imaginary vertical line. Add the handle to the main form. Notice how it helps to emphasize the nearer parts with a slightly bolder line.*

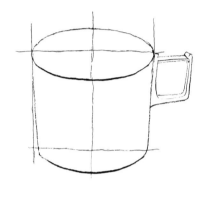

Cylinder *Think of a cylinder as fitting into a perspective box – this will help you with the ellipses. Notice the central guide-lines, particularly on the top ellipse. The front half of the ellipse will look larger than the back half. Bear in mind that ellipses are squashed circles, so they must appear as continuous lines with no 'corners'.*

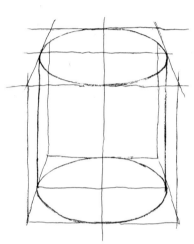

Chair – Step-by-Step (1–2)

Chair Step 1 *This is an example of the 'boxing-up' method. When drawing something like this, try to see it as a series of very basic forms first. Notice how the main parts fit into a number of three-dimensional boxes. Aim for a sort of skeletal construction to the correct proportions, over which you can then add the detail.*

Step 2 *You can build up the actual shapes around the basic framework with confidence, knowing that the underlying proportions and positions are correct. When you are satisfied with the outline drawing, rub out the initial box construction and develop tone and detail.*

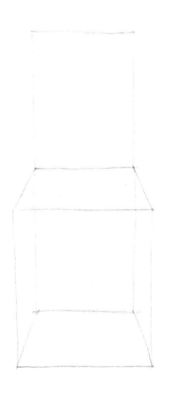

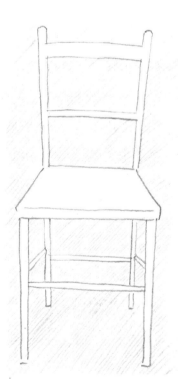

Flask –
Step-by-Step (1–2)

Step 1 *Start with a rectangle whose proportions are based on the widest part of the object and its overall height. Draw in a central guide-line. As this is a symmetrical object it helps to have such a line to work from, so that you can check measurements and positions either side of it and produce a balanced shape. Mark in horizontal guide-lines at those key points where the outline of the object changes direction. From these reference points you should be able to draw in one half of the outline, and then copy this in reverse on the other side. Think in terms of three-dimensional form rather than a flat outline shape.*

Step 2 *Strengthen the outlines where necessary and add shading to suggest the three-dimensional nature of the object. Most of the faint guide-lines will disappear with the shading, while any that do not can be erased.*

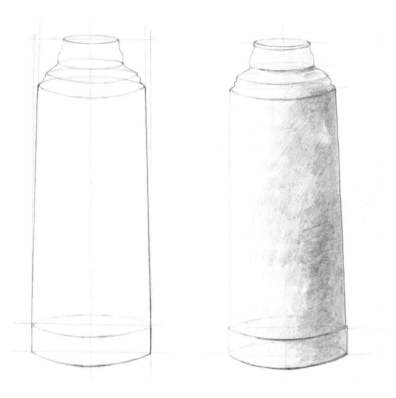

Exercise

Find some simple objects which fit each of the main categories of shapes demonstrated in these pages: box shapes, cylinder shapes and symmetrical shapes. Make 'construction' drawings of each shape using guide-lines to help you plot accurate outlines. Keep the guide-lines faint and make the outlines bolder.

Kettle *This is a more complicated object. The main part of the kettle is almost symmetrical, with the spout, handle and lid added to this. I started with a 'box' based on the maximum width and height of the object and then broke down the area of this into the three main components: body, spout and handle. Look at the various guide-lines I used to help me assess the position and size of one thing in relation to another.*

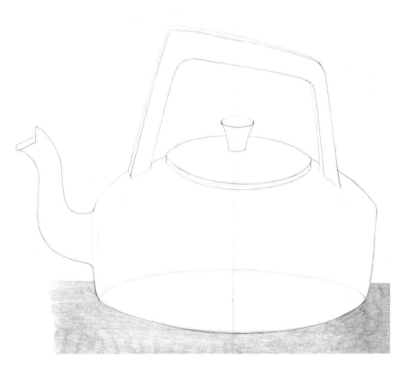

Shapes and Structure

Still Life –
Step-by-Step (1–4)

Step 1 *To begin with, look for the main shapes. Whether the subject is contrived, as in the case of the still life group shown here, or discovered and drawn from life, it helps to view it initially in terms of shape and volume. Half-close your eyes so that you can concentrate on basic shapes. Look at their position and shape relative to each other as well as to the whole picture area.*

For the beginner, a good means of assimilating the overall distribution of shapes within the composition is to make the sort of preliminary drawing shown in this illustration. Start with a series of boxes or rectangles which plot the spaces into which the different objects fit. To do this you will need to assess the proportions, width to height, of each object. These boxes give an indication of the general design and relative position of the shapes. They show the basic layout of the drawing without going into any detail and are easily adjusted if they are drawn too large or too small.

Next, within these boxes, draw in the actual shapes. I suggest you draw these as complete, overlapping shapes, as I have done, so that you can check the position of one object to another. My preliminary sketch was made with an oil crayon.

Step 2 *By following the approach demonstrated in Step 1, you can see that it is possible to build up a very accurate outline drawing from which to work. As I have done, put in whatever guide-lines seem helpful to establish the outlines, and check the position and proportion of things. Use a B pencil, keeping the lines faint at this stage.*

Drawing in the complete shapes helps you to understand the mass and volume of one object against another. It also means that you can check the base area of each shape. Should any bases overlap then obviously something is drastically wrong!

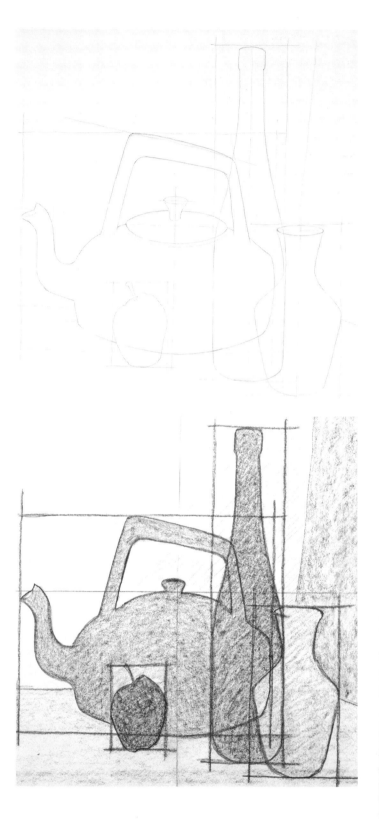

Shapes and Structure

Step 3 Here, I removed the guide-lines and all the other unwanted lines to leave the actual outlines of the objects.

With the problems relating to the scale of the drawing and the actual shapes of the various objects solved, I could now turn my attention to ways of transforming the flat shapes into three-dimensional ones.

First, I considered the source of light, noticing how this influenced the play of weak and stronger tones across the drawing. Once again, half-closing your eyes helps, as it eliminates unnecessary detail and makes you aware of the general distribution of tones. Using the 3B pencil, I blocked in this basic distribution loosely and consequently began to suggest the illusion of form and space.

Step 4 For the final stage of the drawing I made use of all three pencils, especially the 6B pencil for a range of shading effects and the B pencil for redefining lines and adding detail. Also at this stage the putty rubber is useful; use it to reduce tones which seem too strong, to soften edges and blend shading, and to lift out highlights.

Each object can now be dealt with in turn, working from the back. Think not only of tone but also what the object is made of and its surface characteristics. Evaluate the drawing and make any final adjustments before spraying it with fixative.

MATERIALS
For Step-by-Step

- ■ Black oil crayon.
- ■ B pencil.
- ■ 3B pencil.
- ■ 6B pencil.
- ■ Putty eraser.
- ■ 190gsm cartridge paper.
- ■ Fixative.

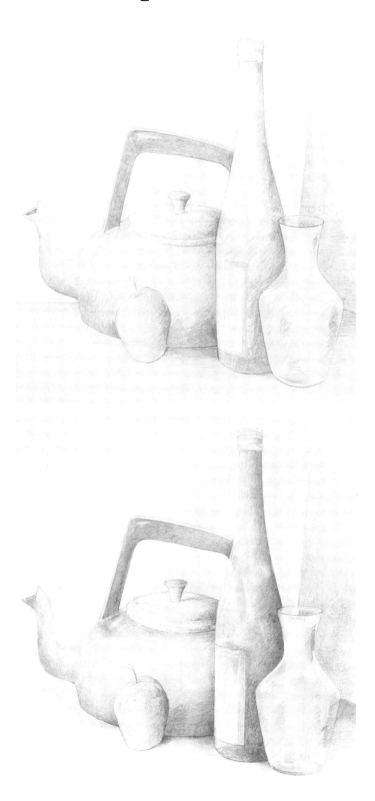

Negative Shapes

In our drawings we usually concentrate on the actual shapes rather than any background spaces or 'negative' areas. In fact, the gaps in and around the main shapes often help in observing the shapes themselves more accurately and therefore assist in the way we draw them. Consequently, as we draw, we should refer to the spaces left between the main parts of the drawing, the background shapes and so on, as another way of checking our observation. When there is difficulty in understanding a particular form, look at the space around it to help describe it more clearly.

Chair *Here, the process is taken a stage further by combining a consideration of the negative spaces with an observation of the actual object. In so doing I evolved a very accurate outline drawing of the chair. However, in resolving the drawing I concentrated on developing the tone and pattern of the background, leaving the main shape as a negative silhouette.*

Of course, in our drawings we must not only think of producing carefully observed studies; sometimes the subject will suggest another form of interpretation. Here, for example, the emphasis is on shape and pattern, and on positive and negative areas.

Nude *The approach in this quick charcoal sketch relied on looking at shapes and spaces rather than measuring accurate proportions and comparing the position of one part in relation to another. Notice how the background areas not only give a very clear indication of the shape of the subject, but surprisingly also begin to suggest some three-dimensional form.*

Try some similar figure sketches in charcoal adopting this approach. Concentrate on drawing the various spaces and shapes of the background and you should end up with a 'negative' yet accurate object or objects set against the more positive background.

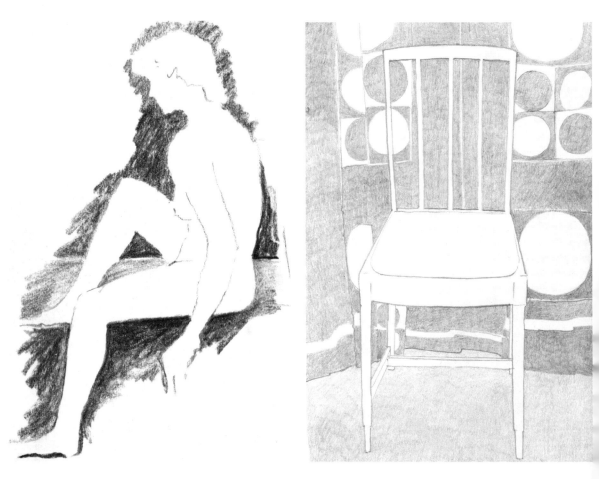

DRAWING IN COLOUR

Media and Papers for Colour Techniques

■ **Coloured pencils.** Buy good quality for general sketching, for more resolved and detailed drawing, and for adding colour to line drawings in charcoal, pencil, or pen and ink. Work on cartridge paper or calligraphy paper.

■ **Water-soluble pencils.** These give a richer colour than ordinary coloured pencils and can also be wetted to produce even tones or wash effects. Ideal for location drawings and for making quick colour sketches and 'notes'. Work on cartridge paper or watercolour paper.

■ **Soft pastels.** Splendid for more spontaneous work and for drawing speedily on a large scale. Pastel is extremely versatile and can be worked over washes and in combination with most other media. Work on Ingres paper, Artemedia paper or a similar textured paper. Black or coloured paper is often an advantage.

■ **Crayons.** These include oil pastels, coloured Conté crayons and wax crayons. Many effects are possible, including sgraffito and resist techniques. Work on cartridge or any coloured paper with a degree of texture or tooth.

■ **Inks and markers.** Try out felt and fibre-tip pens for sketching, as well as coloured drawing inks for more controlled drawings and spray and wash. Work on layout paper, thin card, calligraphy or cartridge paper.

■ **Wash.** Buy a small box of watercolour paints or some small tubes of gouache. A flat wash brush as well as one or two other watercolour brushes are useful for mixing washes and creating textural effects and brush drawings. Work on watercolour paper or stretched cartridge paper.

Colour drawings can be very exciting, but whether or not you choose to use colour mainly depends on the particular qualities of the subject that you wish to emphasize and the overall interpretation you want to give. Some themes, moods, characteristics and effects are obviously best suited to black and white, whilst others need colour.

There is quite a variety of colour techniques from which to choose. Most of the media and methods we have already looked at – such as pencils, pastels, inks, crayons and wash – can be applied to colour drawings. But whilst colour drawings will still involve tone, the relationship of different colours, colour harmony, the intermixing of colours and so on are all new factors to be considered. Mixed-media effects are possible, and with all colour techniques the correct choice of paper or support is all-important.

Testing Materials *Experiment with each colour medium in this sort of way to discover its potential. Here, I tried out a variety of shading, linear and wetted colour effects using water-soluble pencils.*

Materials *Pencils, pastels, inks, markers, crayons and paints will give a wide variety of effects and possibilities in colour.*

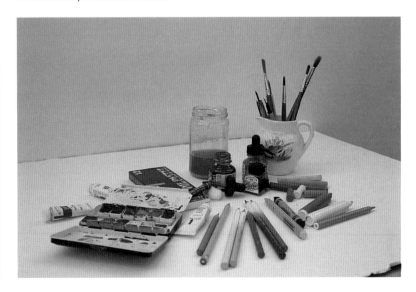

Coloured Pencils

As with most drawing media, the quality and handling characteristics of coloured pencils varies from one manufacturer to another. In general, most have fine, compacted leads that make them ideal for controlled colour work and detail, but the purity of pigment and the range of colours can differ dramatically. Factors such as the type of paper you use, how you hold the pencil and what pressure you apply also play their part. It is a question of finding the make of pencil which best suits the way you work. So, to begin with buy just two or three coloured pencils of several different makes to try them out. Once you have ascertained which brand suits you best, you can add to the range of colours.

Similarly, try out one or two different types of paper. Cartridge paper suits most coloured-pencil drawing techniques because it has a fine tooth and therefore readily accepts the pigment. Coarser grained papers can, however, give interesting broken shading or textural effects. The choice depends on the subject matter and the type of result you want to achieve. A putty eraser is good for lifting out tones and blending; combine this with a plastic or wedge-shaped rubber eraser, which will be useful where precise lines and details need to be removed.

As an introduction to working with coloured pencils, it is well worth spending some time exploring the possibilities for different lines and marks, and practising various shading and colour-mixing effects. You can hold the pencil in a number of ways, from vertical, which creates a firm pressure and consequently a more intense line or tone, to almost horizontal, which is fine for general light shading and sweeps of lines or colour.

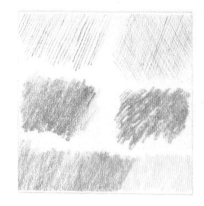

Shading Techniques *The method of shading should be chosen to relate to the intensity of tone or colour required, and perhaps also to the particular surface quality of the subject.*

Practise these five different methods to start with. Working from the top, left to right: hatched shading using a series of closely drawn lines; cross-hatching, shading over the first set of lines at right angles to create a more intense tone; using more controlled and firmer short hatched lines worked into the paper surface; using a scribbling technique; and working over one colour with another.

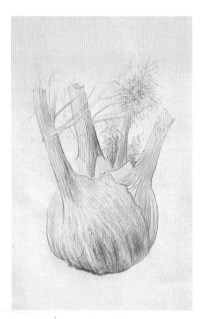

Fennel *In general, it is best to keep to a restricted colour range because this is more likely to succeed in producing harmony and impact in the result. The danger where something becomes very colourful is that the colour dominates and detracts from the underlying forms and real subject matter of the drawing. Simplification to some extent is therefore the key. Pick on the main colours; these can always be intermixed to produce other colours. Creating additional colours this way will maintain colour harmony.*

In this drawing I started with a faint graphite pencil line and then used just four colours to complete the work: green, canary yellow, sienna brown and black. I varied the pressure to give different strengths of colour and worked one colour over another in some places to create the necessary variations.

MATERIALS
For Step-by-Step

■ Staedtler Noris Unipoint coloured pencils: light blue, ultramarine, canary yellow, scarlet, carmine, golden brown, orange, sienna brown, true green and green.
■ Conté Aquarelle coloured pencils: violet, cyclamen, St Michael green, red brown and black.
■ Cartridge paper.
■ Putty eraser and plastic eraser.
■ Fixative.

Summer Cottage – Step-by-Step (1–3)

Step 1 This colourful summer cottage makes an excellent subject for coloured pencils because, as well as the splendid array of colours and textures, it requires some well-defined outlines and particular linear effects, such as for the thatched roof.

It is essential to get some sound shapes to work from as well as a satisfactory general composition, so I started with a faint outline drawing, using an ordinary B graphite pencil. These weak lines are easy to alter, of course, and once established can soon be blended into the initial colour work. To begin with I blocked in the general areas of colour lightly as a basis to work over with the necessary colour intensity and detail in the next two stages.

Step 2 Now it is a question of deciding the colour key – the richness and strength of the colour and where the principal lights and darks occur. There is a particularly rich mass of green behind the cottage to the left and the strong shadow under the eaves contrasts forcefully with the light on the whitewashed walls and the foreground stonework. By establishing these areas I could fix the range of colour for the whole drawing.

Step 3 Having built up the colour in a general way and having decided on the range of colours and tones involved with some key areas as reference, I could now work more systematically across the drawing.

Starting with the sky area and moving diagonally towards the bottom right-hand corner, I strengthened the colour where necessary and added or suggested detail. And I was not afraid to exaggerate colours where I thought it would help to do so – for example, in the bottom left-hand corner!

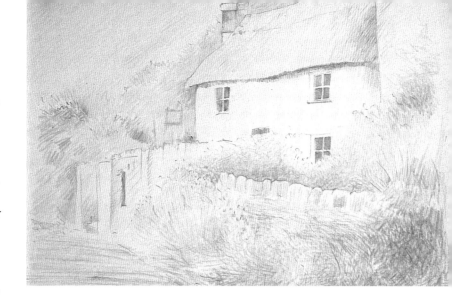

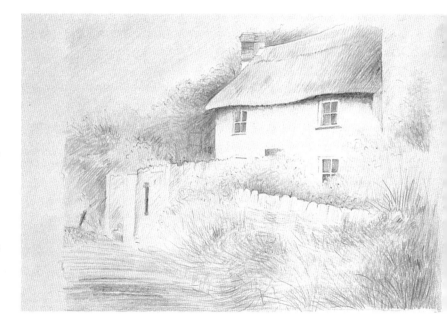

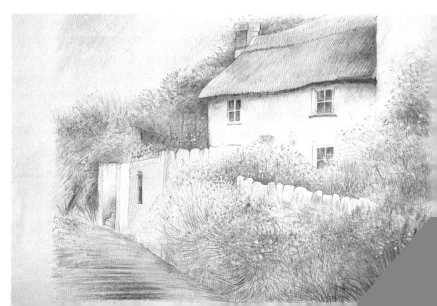

Water-Soluble Pencils

More versatile than ordinary coloured pencils, water-soluble or aquarelle pencils can be used to create interesting combinations of weak washes of colour with stronger tones, as well as different textural effects. Additionally, when used in conjunction with watercolour, inks or pastels, they will give some exciting mixed-media results.

Water-soluble pencils worked on 190gsm cartridge or watercolour paper will enable denser and richer colours to be built up, with the advantage that, where required, these can be wetted and transformed into flat or blended washes. The pencil-shaded area is simply painted over with a soft watercolour brush loaded with clean water; this dissolves the colour and enables it to be reworked in a way similar to watercolour.

Cobbled Path – Step-by-Step (1–3)

Step 1 *Using the B pencil I began by sketching in the principal shapes faintly and planning the overall composition.*

Next, keeping to the five main colours (light blue, dark green, red brown, violet and olive green), I shaded in the general underlying colours. There is no need to be at all fussy at this stage: look for the main patches of colour. Applying the colour in hatched lines, especially for the sky area, enables some variation of tone to be achieved when the colour is wetted.

Step 2 *Wet these areas of colour and modify them into more subtle basic washes. I used a no. 6 watercolour brush dipped in clean water. Wet the brush but do not overload it. Agitate the brush slightly to loosen the colour and work it into a wash. Dip the brush in clean water for each new colour. Leave to dry before beginning any further drawing.*

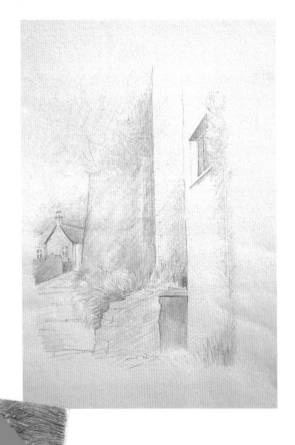

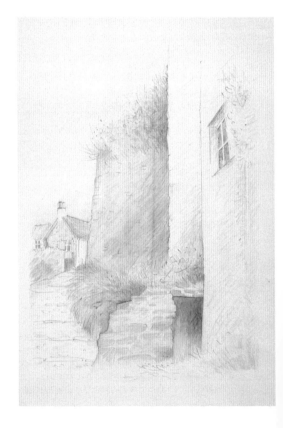

Water-Soluble Pencils

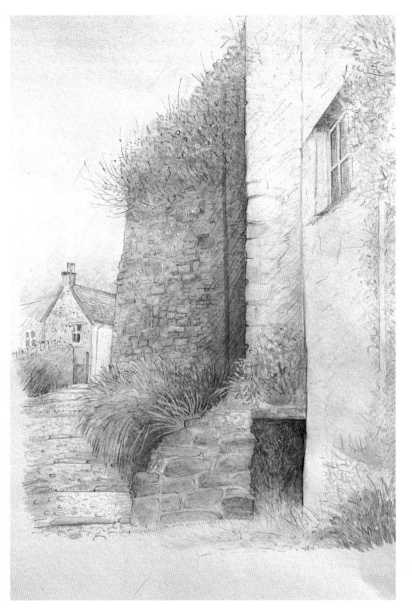

Step 3 *The final stage is to develop each area with the appropriate detail and effects. As in all drawing, contrast is important. Here, I tried to achieve a contrast both in the use of light and dark as well as in the surface textures and details.*

Once the underlying washes have dried, further dry pencil work can be added. Keep the pencils sharp. Rather than completely finishing each area in turn, my approach is to work across the drawing and then return to any part that needs further attention, for I prefer to see the drawing evolving as a whole. So, using the full range of pencils listed in the materials box, I added more lines and shading, including redefining some of the outlines with the B pencil. Any parts which become too intense in colour can be toned down either with a putty eraser, or by rewetting and then using a dry brush to lift off some of the surplus colour.

Pastels

Pastel is a terrific medium for speedy, on-the-spot drawings, and I particularly commend it for landscape subjects and sketchbook studies. Techniques range from subtle line-drawings to well-resolved works using blended and superimposed colours, and perhaps even aquarelle and mixed-media effects. Pastel encourages freedom and spontaneity, so work on a large scale if possible.

With any pastel subject, choosing the right type and colour of paper is very important (*see* page 21). In the majority of cases, the colour of the paper will show through in the drawing and this should therefore be selected with regard to the desired effects and tonal range. When using a single stick of pastel, the paper colour can be used as the tonal extreme for the highlights or darkest areas of the subject. In other cases, the paper may be chosen to suit the general background tone or to enhance the result.

Exercise

Try the basic strokes and blending techniques shown here. Then experiment further and involve combinations of colours and methods. Work through the sequence illustrated:

■ Start with dots or dabs of colour. Spacing and pressure will influence the intensity of colour with this method. Try dotting one colour into another to create a sort of pointillist effect.
■ Try straight lines of different intensity (pressure) and wider lines drawn with a square-section pastel or a short stick used on its side.
■ Shade with hatched and cross-hatched lines.
■ Blend two colours together by overshading one colour with the next.
■ Blend two colours together by smudging one area of colour into the adjacent one using your fingers, or a piece of paper or cotton wool.

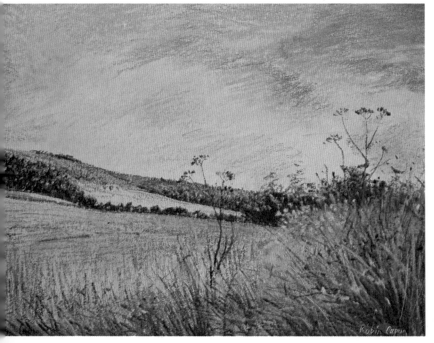

South Downs *Colour is an important aspect of the landscape, but many landscape artists underplay what are often quite vibrant colours. Make the most of the rich colours of nature, especially when enhanced by the bright sun of midsummer, as in this example.*

For this drawing I used mostly half-length round, soft pastels, choosing a limited range of colours which included olive green, hookers green, lemon yellow, burnt sienna, burnt umber, cadmium red orange, Prussian blue, cobalt blue and white. The technique used was to draw mostly with hatched lines (evident in the sky and foreground), blending these in where necessary with a cotton bud. For very weak patches of colour, try shading some of the appropriate colour on to a piece of scrap paper first, then dipping your finger into this and lightly rubbing it on to the drawing.

54

Pastels

Woodland Track – Step-by-Step (1–2)

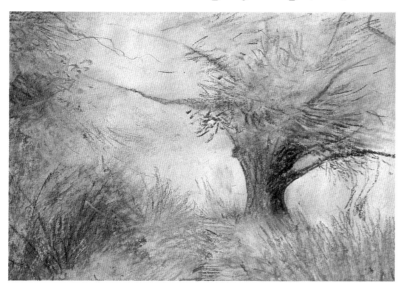

Step 1 *I used heavy quality white cartridge paper for this drawing. This enhances the richness of the colour and provides a surface with sufficient tooth to hold the pastel, yet allows quite smooth, weak areas of colour where required. Using just three or four colours I blocked in the general colour masses first.*

Step 2 *The first patches of colour were mostly rubbed into the surface of the paper, these giving a good base on which to work. I then drew over and into these foundation colours using a combination of lines and dots of colour. Pastel can be worked into highly finished results, but some subjects, especially landscapes, are best left as an impression of mood.*

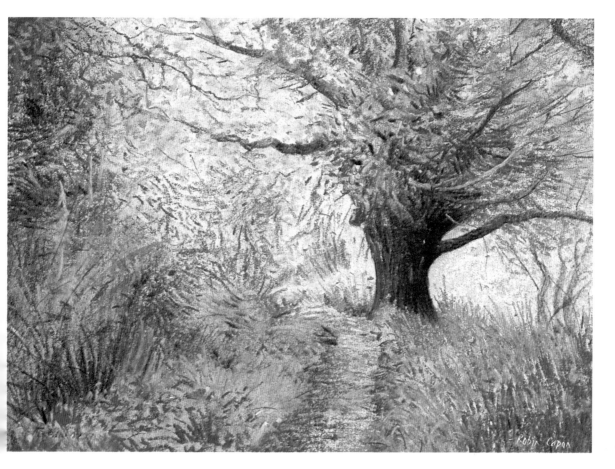

Oil Pastels

Oil pastels are amongst the most direct and independent of the colour drawing media, and suit bold, colourful and decorative ideas in particular. They do not necessarily need any colour mixing, nor do they rely on the addition of solvents or diluents. And whilst oil pastels and smooth card are not a happy combination, they will work satisfactorily on almost any other paper surface. So, a few sheets of paper and a small box of oil pastels are all you need for a good variety of work.

To get to know the medium, start by trying out the basic techniques shown in the illustration on the right. You will also find that you can smudge the colours together with your fingers and blend them into a 'painterly' effect by adding white spirit or thinners. Other interesting textures can be achieved by scratching through thick layers of oil pastel with a sharp point or the blade of a craft knife. Many unusual and exciting techniques are possible. Finally, try exploiting the texture of heavy quality papers as well as coloured papers.

Still Life – Step-by-Step (1–3)

Step 1 *As an introduction to this medium I recommend you try something straightforward like the still life group I have chosen. Select two or three contrasting objects placed against a simple background. Look for some scope in the colour and the opportunity to try out one or two different techniques.*

I drew the main outlines in pencil first and, as you will see from the lower half of the drawing, I kept to simplified shapes. Next, I started to block in the main colours using a light, hatching technique. It is important to work from background to foreground to avoid smudging.

Step 2 *The initial shading in with the various colours has been completed. Looking at the group I decided to incorporate a number of techniques to suit the different objects and surfaces. For the background I decided to stick to the hatched line technique to suggest light areas and dark shadows; less intense colouring here will help bring the objects forward. For the variations of tone on the bottle I decided to use the scratching out method for highlights, overworking in several layers for the more solid tones. The orange needed several overlaid colours to create its particular colouring and form, and the foreground had to be built up really thickly with an almost oil-paint texture to contrast with the rest.*

Template Design *A simple design such as this is a good way to get to know some of the handling characteristics of oil pastels. Cut out a template from folded paper and draw around it. Do not make the design too complicated, but do include some small shapes. Shade in each area with a different colour and try some colour-mixing effects by overshading one colour with another. Keep the edges as neat as you can – you will find that it's not as easy as it looks!*

MATERIALS
For Step-by-Step

■ Oil pastel colours: grey, brown, pale orange, pink, white, pale blue, green, yellow and red. I used Cray-Pas oil pastels.
■ Thin stretched cartridge paper.
■ B pencil.
■ Green and blue coloured pencils.
■ Sharp craft knife.

Oil Pastels

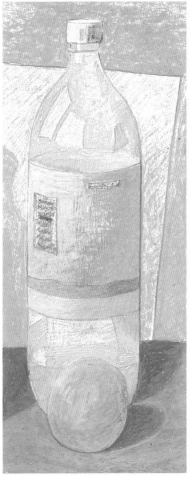

Step 3 *Each area is developed in turn, always working over or against the shape behind so that you get the definition required and avoid smudging. Therefore, for this subject the procedure is: background, bottle, orange, foreground.*

The highlights on the bottle were made by letting some of the paper texture show through the light shading and by scratching into the pastel colour. For some of the small areas of dark tone I shaded over the green pastel with a dark green Conté pencil. Other deep tones were made simply by applying more pressure and building up a thicker application of pastel. Outlines, where essential, were drawn in with appropriate coloured pencils.

From the underlying yellow, the form of the orange was developed by the addition of pale orange and pink, using a touch of brown for the dark side and white for the highlight. The solid foreground area consists of layers of brown, pale blue and grey.

Techniques *As usual, test out the medium before you try an actual drawing. See what marks, tones, colour-mixing and colour-blending effects are possible. Try a small test exercise such as this. From the top, the techniques are: shading with a length of pastel used on its side; lines and solid shading; overshading blue with green; and scratching into the oil pastel with a sharp craft knife.*

Additionally, you should see what variety of lines is possible, from weak, sensitive lines using just the angled corner of the pastel, to wider and more intense lines. Colour mixing can also be achieved by dotting one colour into another and by brushing on a solvent such as thinners.

Tips

■ Because of their oily nature, these pastels quite easily pick up specks of other colours. Keep each oil stick clean by wiping it occasionally with a cloth or piece of kitchen paper.

■ Similarly unwanted particles of crayon may stick to the wrong parts of the drawing! Blow these clear or flick them off with a soft brush or cloth.

■ Fixative spray will prevent finished drawings from smudging.

■ When you store oil-pastel drawings, separate each one with a protective sheet of thin paper.

Inks and Markers

You will find that most art shops stock quite a variety of coloured drawing inks and acrylic inks. These can be applied with a pen or brush for specific, direct drawing. Use a dip-pen with the coloured inks for small drawings and detail work, and try using a brush (either a soft watercolour brush or a stiff-haired hog brush) for more expressive results. Indeed, pen and brush techniques can be combined, as in the illustration below, to give well-resolved colour effects.

Drawing inks can also be diluted for washes, spraying, spattering, stippling and various texture and offset techniques. When mixing washes of ink, add just a few drops of ink to a quantity of clean water – ink colours are very strong and need a lot of diluting. You can work a colour wash into a previous wash which is still wet to create diffused effects and colour mixes, but permanent inks will not mix with subsequent washes once the colour has dried; like everything about the properties of materials, this is a fact to exploit if possible.

Marker pens are also available in various types, some with permanent ink and some water-soluble. Experiment with one or two individual markers first to see how they handle and what sort of marks, colours and effects can be created. Markers are fine for quick line sketches and for establishing preliminary ideas. Use a marker pad or a similar thin, smooth paper or card for markers, and a more absorbent paper, including coloured watercolour papers, for ink washes.

Onions *Ink is very versatile and combines readily with other media. This drawing started with a pen-line framework and was developed with acrylic ink washes and Chroma Artists Colour.*

Macaw *Most of this drawing was made with ordinary fine felt-tip markers. I started with a faint pencil outline and then worked down the drawing from head to tail, completing each colour area in turn. Although markers are not the most sensitive of drawing materials, varying the angle at which you hold them and the pressure you apply will give a range of marks.*

Inks and Markers

Spraying

You can spray ink and thin paint on to a drawing to create general background effects, give texture to specifically masked-out areas, or, as in the still life illustrated above, to provide the basic colour shapes over which to work. For this example I used undiluted drawing ink and diluted powder paint applied with a metal spray diffuser. The procedure is as follows:

■ Cut paper shapes or templates to mask out specific areas of the drawing. These may need to be very precise shapes so that the spray is confined to certain areas. Remember that you are masking out the negative areas. If necessary, make a tracing of these areas and then cut them from paper.
■ Attach the paper masking or templates to the drawing with small pieces of Blu-Tack.
■ Prop up the drawing and mask the surrounding area with newspaper.
■ Dip the spray diffuser in ink or diluted paint of the correct colour and, from a distance of about 25cm (10in), blow through the diffuser to create the spray. Experiment to master this technique.

Trees and Bridge *Ball-point pens also make good drawing tools. You can work in monochrome or combine several colours. The more expensive pens with replaceable refills are most reliable; they generally give more subtle lines and tend not to clog or leave unwanted blemishes.*

This drawing was made directly with the ball-point pen, this being used in various ways to give a range of tonal effects, lines and textures. Pressure is the key factor here: light pressure, the pen just skimming the surface, gives weak, sensitive lines; heavy pressure gives dense tones. The foreground water area was treated with a white wax crayon for a resist effect, and the final drawing was enhanced with washes of diluted drawing ink.

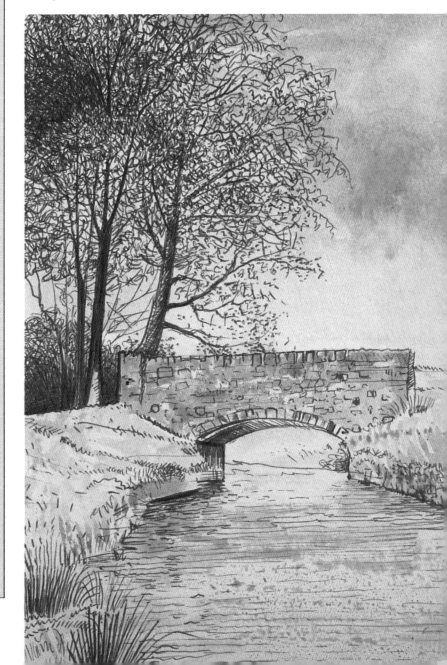

Line and Wash

Drawings which are primarily made in line with a pen or pencil can be enlivened and developed with the addition of colour washes. As well as being a technique and style which can be used in its own right, line and wash is a splendid method for sketchbook work and location studies, where it may be necessary to set down as much reference information as quickly as possible.

Two factors play a decisive role in making line and wash drawings: the sort of pen or pencil you use,

and the type of paper. For crisp, well-defined lines, use a permanent drawing ink, such as Indian ink, or ordinary graphite drawing pencils. Some technical drawing pens and art pens have ink which is permanent, but most fineline and fibre-tip pens do not; similarly, there are water-soluble pencils. Wash which is applied over these materials will cause the lines to blur – a characteristic which can, of course, be exploited in the drawing. Choose a paper which is not too absorbent, yet will still take a wash – cartridge paper is ideal.

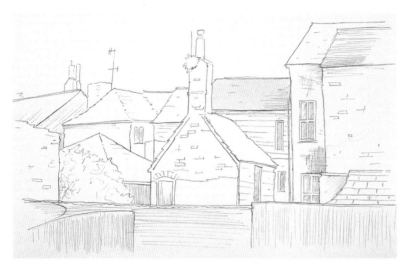

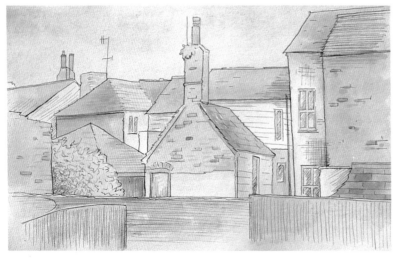

Buildings – Step-by-Step (1–2)

Step 1 *With their well-defined shapes, buildings and still life subjects are ideal for this technique. The method here is to start with a pen line-drawing and then add colour. The alternative, with subjects such as a landscape which isn't quite so defined, is to begin in a looser way with some general washes of colour, pulling the drawing together by adding lines over these when they have dried.*

I started with one or two very faint pencil lines just to fix some key points in the drawing. Next, I worked with a Gillott dip-pen and Indian ink to draw in the outlines carefully. Essential shading and detail was indicated with hatched lines and other pen techniques. Keep the lines fine and don't overwork this ink-drawing stage or the dark lines will dominate the colour rather than complement it.

Step 2 *Once dry, I added very weak washes of colour to the drawing. Keep these as flat, controlled washes, wetting each area just sufficiently to cover it. Here and there a shadow or richer tone can be achieved by applying a second coating of wash. In general, limit the colour range and keep it simple!*

Line and Wash

Wheal Betsy – Pencil and Wash *I find this an excellent technique for making really useful studies out on location. I can work from these at a later date and translate them into watercolour, oils or any other colour medium. All the essence of structure and detail is in the pencil drawing, with the colour washes added quite quickly at the end to liven up the result and give some colour reference.*

This is a subject which is interesting from different angles and, of course, seen in its landscape setting. I decided to make four studies, three from contrasting viewpoints and one of a close-up detail. Rather than do these on separate pages of a sketchbook, I felt it would be better to see them on the same sheet. Therefore, I used an A2 sheet of cartridge paper so that I could view them as a group and readily make comparisons.

Most of the drawing was done with a 6B sketching pencil, this kept very sharp. The advantage of a very soft pencil is that it allows a wide range of marks and tones and, I find, encourages decisive work. As with the pen drawing on page 60, all the detail and shading was done at this stage.

For the wash colours I used just three basic watercolours: cerulean, hookers green and raw sienna. These can be intermixed to create other colours, as in the stonework, but in the main the washes should be kept weak and uncomplicated.

Mixed-Media Colour

Occasionally you will find that it is necessary to combine several media in order to convey the variety of colour effects you want. Mixed-media work obviously relies on a sound knowledge of a range of techniques, and therefore you need to practise with individual tools and materials first so that you can become really familiar with their different handling characteristics and how they respond to various types of paper.

A breadth of experience is an advantage. The previous pages in this section on colour have introduced work in pencils, crayons, pastels, inks and wash techniques. If you have experimented with these and tried out the ideas and exercises suggested, then you will have a useful foundation knowledge of the contrasting characteristics and qualities, and will no doubt

have realized the potential for combining media.

Mixed-media effects will give very lively and interesting results but, as in all drawing, the key to success is knowing when to stop. It is often tempting to get carried away by the effect one medium has on another, and consequently to lose track of the essential idea and impact of the drawing. For this reason, mixed-media work needs more preliminary thought and planning than most other drawing projects. Think of the sort of colour effects you want and choose the media and techniques to suit these. I suggest you start with just two media – oil pastel and ink or wash and ink, for example. But don't be afraid to experiment and make mistakes! Technical considerations also play their part – you need to think

about how the different media and techniques will work together and what sort of paper will best respond to the mixture you have in mind.

MATERIALS
For Step-by-step

- ■ B pencil.
- ■ Blue watercolour wash.
- ■ Conté Aquarelle pencils: black, violet, blue, bistre, dark green, St Michael green, olive green.
- ■ Soft pastels: hookers green (light and dark), olive green, cadmium yellow, cadmium red, burnt sienna.
- ■ Mapping pen and Indian ink.
- ■ White wax crayon.
- ■ Stretched cartridge paper.

Teapot *Now and then it is good to use materials which can't be erased and which therefore encourage a free and spontaneous approach. This lively line drawing used wax crayons for the general outlines and to give a suggestion of colour, and a green felt-tip pen for the decorative details.*

Mixed-Media Colour

Gateway View – Step-by-Step (1–3)

 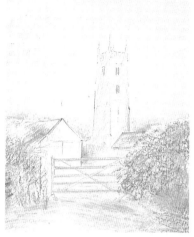 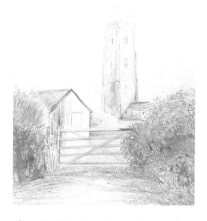

Step 1 As an introduction to mixed media, choose an idea such as this – something that isn't too complicated in composition and detail, yet has a variety of surfaces and effects. Working on stretched cartridge paper, I sketched in the general idea and worked a wash of thin blue watercolour across the sky area. I used just a touch of white wax crayon on the church tower and shaded over this with bistre Conté pencil.

Step 2 The remaining areas were then blocked in with the Conté pencils and pastels. I used the Conté pencils for the weaker, less textured areas, and the light and dark hookers green pastels and the burnt sienna for the more textured foreground shapes. This drawing gives an impression of how I wanted it to look and, where necessary, I worked over these preliminary colours to enhance and sharpen the final result.

Step 3 Here, I worked on the tower by wetting the aquarelle pencil shading and thus creating a resist texture effect because of the wax crayon beneath. When dry, further pencil detail and shading was added to this. The colour in the other areas was enriched, with accents of red, and yellow pastel used to liven up the foreground. One or two pen and ink lines were added to suggest detail and to sharpen edges.

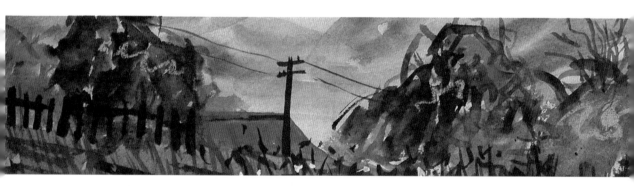

Landscape One of a series of quick sketchbook studies, this is reproduced about two-thirds actual size. Most of this drawing was made with a brush and watercolour which, when dry, had one or two pastel lines added to it to enliven some of the darker areas and maintain the general spontaneity.

 Ink or watercolour wash makes a good foundation for many mixed-media techniques. You can draw over the dry wash with pen and ink, crayons, pastels, pencils and markers.

 In addition to the different media described in the previous pages, you will discover pastel pencils, Oilbar and oil crayons, various aquarelle crayons and other interesting colour drawing materials. Variety adds to the scope and enjoyment of your work, so try them all if you can.

Expressive Colour

The previous pages show a variety of colour media and techniques. Colour is an exciting element of drawing, and in consciously choosing to use colour we are regarding it as essential to interpreting the subject in the way we wish. Usually, the use of colour will support the involvement of tone, perspective and so on to translate what we observe into an accurate drawing.

In our personal assessment of what is important in the subject and what we should like to stress, we may, however, decide that colour is the overriding force. We can exaggerate or simplify the colours we see to create a particular emphasis or mood in the drawing, and we should not be afraid to use colour positively and individually. One vital thing about colour is not to work with preconceived notions. For example, we know that a tree is green, but we should not let this fact influence how we look at each individual tree and the colours we see there.

Nudes *Expressive work has no boundaries, and drawings can incorporate many other techniques and disciplines such as collage and painting.*

Here, expressive colour is combined with a particular technique to make an interesting and visually powerful result. This drawing is an assemblage of two separate drawings. The original drawings, of equal dimensions, were cut into strips and, taking a strip from each drawing in turn and gluing it to a backing sheet, the new design was created. The drawings were made with Conté Aquarelle pencils.

Trees *Using water-soluble pencils enhanced with watercolour, I kept to an almost monochrome approach here in order to convey the mood of this twilight scene. The choice and use of colour is the dominant aspect of this drawing, the colour being both bold and evocative.*

Different colours do prompt different moods and responses. Test this out by making a monochrome drawing of the same subject, first in a warm colour such as red, and then in a cool colour such as green.

PERSPECTIVE AND SCALE

In representational art, artists have always had to confront the problem of how to depict three-dimensional objects and space on canvases or sheets of paper which are two-dimensional. Where receding straight lines are involved, perspective is one way of suggesting depth. However, other factors and techniques play their part, and perspective will often be used in conjunction with scale, proportion, foreshortening and maybe the use of tone, colour and detail. Even when we are drawing a single object, it helps to set it in some kind of simple background with one or two other shapes to give a comparative relationship of scale and distance.

Look at the information on the next few pages and learn to appreciate the circumstances in which perspective will be an influence. Understand the theory, but do keep a balance in the way that this is used so that your drawings don't look mechanical and unfeeling.

Cubes *This simple exercise in drawing a cube proves the need and significance of perspective. In the top drawing the cube has been drawn isometrically, that is with all of its edges the same length. However, despite the careful use of tone, it lacks three-dimensional form. There is little recession – indeed, the sides appear to get wider as they go back.*

We know that the top and bottom edges of each side of the cube are parallel, but we cannot draw them like this if we wish to suggest depth. As in the lower drawing, perspective will influence such shapes. In perspective, the parallel lines of an object which is at an angle to us will eventually meet. Drawn in perspective, the cube has sides which taper back slightly, this giving a much more convincing suggestion of form and depth.

Perspective

This is a drawing device for creating the illusion of three-dimensional form, space and distance on a flat surface. Perspective applies to subjects such as buildings, which have straight-edged or parallel sides and are set at an angle to the viewer. The basic principle is that receding parallel lines appear to converge. Perspective does not normally apply to vertical lines.

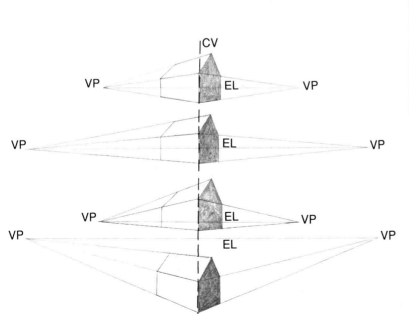

Houses *Here we see the use of perspective applied to a house shape drawn from different viewpoints and with the nearest corner as the centre of vision (CV) in each case. The complete lines of perspective have been drawn in to show that they do eventually meet at a point, known as the vanishing point (VP), on the horizon line or at eye-level (EL).*

Perspective in Action

The use of perspective isn't just confined to the obvious subject with parallel sides that is viewed from an angle; it can apply in a more subtle form in other situations. It is as well to remember that anything drawn from an acute angle will have a shape which is distorted, foreshortened or exaggerated in some way. For example, an ellipse, (*see* page 44) will be influenced by perspective.

Artists often refer to one-, two- and three-point perspective. The drawing of the chair on page 44 is an example of one-point perspective. This is because we are looking straight at the front of the chair and consequently only the seat, which recedes front to back, has to be drawn in perspective; there is one set of perspective lines and one vanishing point. Angled buildings, such as the houses shown on the previous page, will have two sets of perspective lines and thus two vanishing points (two-point perspective). A very tall building viewed from the ground could have perspective applied to its tapering height as well as to its angled sides, therefore having three sets of lines and three vanishing points (three-point perspective). Now study the other perspective examples on these two pages.

Summary

■ Use perspective on any object or part of an object which has straight lines or parallel sides running back into the distance. This could be a chair, a building, a brick wall, a road and so on.

■ In general, exaggerate the perspective slightly in order to suggest depth, space and three-dimensional form convincingly.

■ Normally you will not draw in the lines of perspective, but you could use a few guide-lines to help check angles and directions.

Moorland Track *It is not just man-made things such as railway lines and motorways which demonstrate the need for perspective. Natural subjects such as meandering rivers and mountain tracks do not have parallel sides, but they may still need quite an exaggerated tapering effect to suggest distance.*

Thatched House *A subject like this follows an obvious direction of perspective, and it is worth using some preliminary guide-lines to help check the different angles. Note that the vanishing point is well outside the picture area.*

Monmouth Bridge
– Step-by-Step (1–3)

Step 1 *There seems little obvious perspective in this subject, and although few perspective guide-lines can be drawn in, each part of the drawing is at a different angle to the rest and thus has its individual perspective considerations. The two main buildings (the archway over the bridge and the building to the right) are set at different angles to each other, their perspective lines consequently leading to different vanishing points.*

Begin by assessing how each component in the scene relates in position and direction to the next. Use some weak guide-lines to establish the main angles and sketch in the general outlines.

Step 2 *Erase unnecessary guide-lines and think about the general areas of tone. Here, I worked over most of the pencil outlines with a hard charcoal pencil, keeping this well sharpened. Bolder lines were used for outlines and edges in shadow or in need of greater emphasis. Used on its side, the charcoal pencil gives a good, light, general shading and a richer tone than the softer, thick charcoal used for the foreground.*

Step 3 *Complete in the usual way by working back into the drawing, adding detail and developing tones. Make use of contrasts and exaggerate these if necessary. Notice how a clear appreciation of perspective gives structure to the drawing as well as a sense of form and depth.*

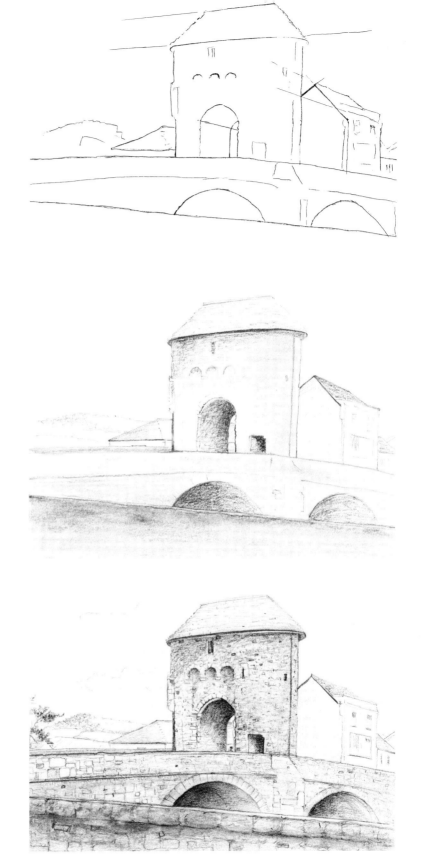

MATERIALS
For Step-by-Step

- ■ B drawing pencil.
- ■ Charcoal pencil (hard).
- ■ Stick charcoal.
- ■ Cartridge paper.
- ■ Fixative.

Scale and Proportion

How we relate the size of one thing to the next is another way of suggesting depth in a drawing. In a landscape, for example, the inclusion of the human figure, which is a size familiar to us, will set the scale of the whole scene. Similarly, scale and depth can be achieved by composition devices such as a row of trees or fencing posts which lead the eye into the picture and, as they get smaller and smaller the further away they are, at the same time suggest great distance. The relative scale of different things within the drawing is therefore important from a composition point of view and with regard to conveying successfully a sense of space and distance. In this context it helps to think of the edges of your sheet of drawing paper as a kind of window frame through which you are looking into the distance. Obviously, those things near the bottom edge of the drawing are the nearest.

As an aid to drawing something the right size, make use of guide-lines which plot its position and size in relation to other parts of the drawing. Have another look at page 46 to see how this is done.

Matchstick Figures *Quick, skeletal-type figures such as these help to check proportions and stance. This simple framework can be altered as necessary before the main drawing is developed. Remember, the height of the human body is equivalent to about eight heads. Check other proportions and positions in this way.*

Figure Proportions *You can elaborate on the matchstick technique to put in whatever guide-lines help to plot the size and position of one part in relation to another. In a subject such as this reclining nude, look for angles and movement as well as basic proportions.*

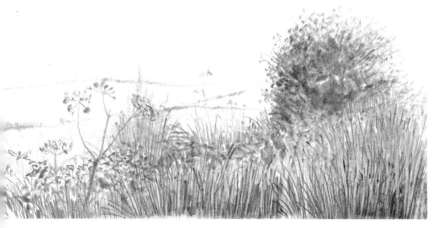

Landscape *Your viewpoint will also play its part in influencing contrasts of scale. A low-angle viewpoint, as in this landscape, tends to exaggerate the size of foreground shapes in relation to the rest. This can be used to advantage for creating interest and impact in the drawing and for suggesting great distance. Notice, too, that dramatic changes of tone and detail also convey a sense of depth, with foreground shapes stronger and more detailed than those further away.*

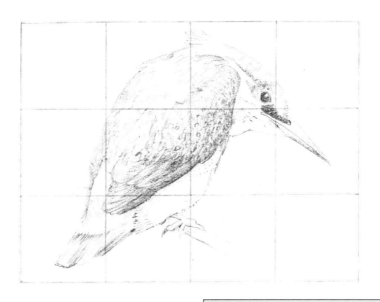

Enlarging in Proportion *To measure a sheet of drawing paper in proportion to a smaller sketch, put the sketch in the corner of the larger sheet and place a straight-edge diagonally across it. The paper can be squared-off at any point on the extended diagonal and will be in proportion to the original.*

Houses *Dramatic contrasts of scale can suggest tremendous distance within a relatively confined area of the drawing. However, this isn't necessarily as easy as it sounds because the drawing must make sense. Overexaggerated scale may simply look absurd and ruin the credibility of the work as a whole.*

In this pencil and charcoal drawing my viewpoint was slightly uphill and I wanted the houses on the left to look quite distant. I think I have managed to get away with the sudden change in scale, but other factors played their part in supporting this. The perspective of the windows on the right and the angle of the top of the wall help to divert the eye back into the distance quite sharply. Equally, the mass of foreground detail attracts most of our attention, whilst the distant houses are quite sketchy.

Squaring Up

This method will help you transfer quite accurately the drawing in a sketch on to a larger sheet of paper

■ Take the original sketch and divide it up with a grid of squares like those shown in the illustration above. If you wish to preserve the sketch intact, cover it with a sheet of tracing paper first.

■ Keep the number of squares to a minimum otherwise the process will become too involved and time-consuming.

■ Cut a sheet of paper in proportion to the sketch and divide it into the same number of squares. Obviously these will be much bigger.

■ Look at each square on the original sketch and redraw the part of the drawing in that square on a bigger scale to fit the corresponding square on the larger sheet. Stick to outlines and important features.

■ When you have drawn the outlines you want, rub out the faint grid lines and develop the rest of the drawing in the usual way.

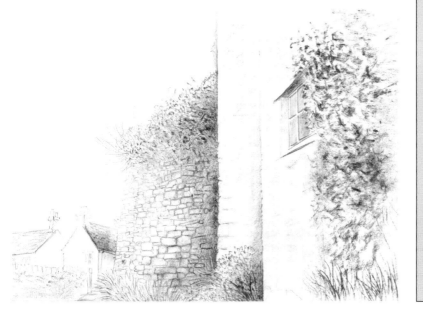

69

COMPOSITION

Composition is the way we organize the different shapes or content of our drawings into a particular layout or design. A composition may be contrived, as in the arrangement of objects in a still life group, or it may depend on choosing the best viewpoint or selecting the best part of a subject on which to concentrate our attention. It is often necessary to simplify or exaggerate what we see in order to create an interesting and effective composition.

In general, the aims of good composition are to give some drama or impact to the idea by leading the eye around the drawing, keeping the attention within the picture area, and focusing on a point of particular interest. Composition is therefore an important factor in the success of any drawing.

Whatever you decide to draw, your initial thoughts should include some consideration of composition. Not only the highly complex subjects require some planning – even if you are drawing a single object you need to think about its size and position on the paper and how it relates to the background. In landscape drawings the proportion of land to sky may be your main concern, with a figure composition it could be the balance between the figure and background, and with a still life it may be the relationship of shapes within the whole.

Whilst there are points to watch and things to avoid in composition, as with perspective, it is best not to become inhibited by theories. Simply be aware that you are designing with shapes and that they should 'read' in an interesting way.

Summary

■ Make some simple roughs or diagrams to help plan your composition and enable you to look at various alternative designs.

■ Consider which way round you need your drawing paper. What size and shape will fit the idea best?

■ Avoid basic divisions within the picture area which will make the composition too balanced and symmetrical.

■ Use lines and shapes which lead to a main focal point. Counteract anything which leads your eye out of the picture.

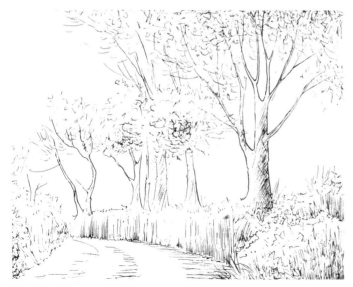
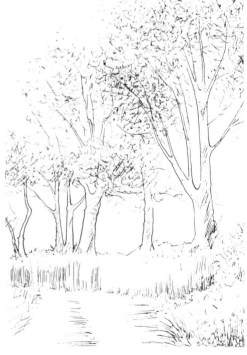

Devon Bank *When examining a subject to draw, do not be afraid to try out different viewpoints and to consider using the paper either way round. It is a good idea to make some composition roughs, like the two pen and ink drawings shown here, so that you can try out several design alternatives before making your final larger and more resolved drawing.*

Experiments in Still Life

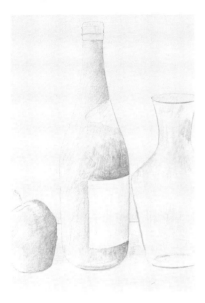

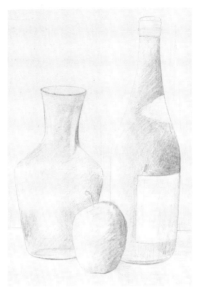

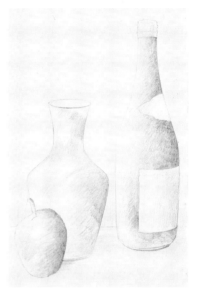

A poor composition because the objects are arranged in a straight line and disappear off the edge of the paper. The scale and/or positioning of objects needs more consideration.

A better arrangement but still too balanced. The apple is exactly central, overlapping equally on the other two objects, which are level.

A more interesting arrangement that makes use of the diagonal, but not too obviously so. However, the bottle looks too detached from the rest of the objects.

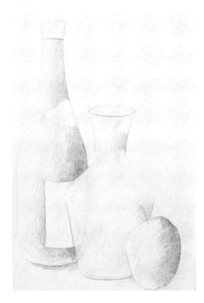

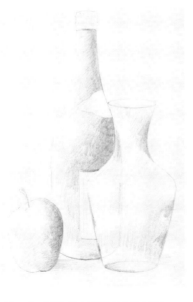

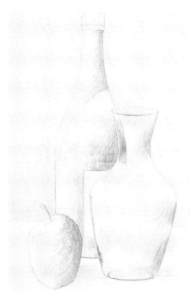

More together as a group but much too symmetrical as an arrangement, with the diagonal or triangular composition overplayed.

Here the bottle is central and its edge conflicts unhappily with that of the top of the vase. The base of the vase is level with the bottom of the apple.

A much more pleasing arrangement. Slight adjustments to each object have created an interesting relationship of shapes and a better overall grouping against the background.

IDEAS AND INSPIRATION

When you start learning to draw you soon realize just how much there is to find out about materials and techniques, perspective, how to look, see and interpret, and all the other different skills of the craft. To draw well you will need to know about all of these various aspects and use them appropriately for every drawing you make. Indeed, problems solved in each new drawing will add to your knowledge and development. And this goes on – there are always things to discover and learn.

Gradually, as your drawing develops and you gain confidence, you will start to find a direction in your work, with a type of drawing and perhaps a particular subject matter that interests you most. Don't be afraid to build on such an interest, for in this way you can develop a style of your own, a way of seeing and interpreting which is marked with your individual personality.

The choice of subject matter is, of course, a very personal thing, ideas and inspiration coming from many sources. Whilst, for example, one artist might be moved by the scale and beauty of a landscape view, another will be impressed by the tonal qualities of a formal still life group. You will have your own preferences for suitable subject matter, but don't be tempted into too narrow a range. It is easy to play safe and stick to tried and tested ideas, but after a while these will not present a challenge and consequently, as well as failing to test and extend your abilities, they will result in rather tired and unimpressive results. There is no shortage of ideas, so do not be afraid to experiment and certainly do aim to be a little ambitious with every new drawing you make.

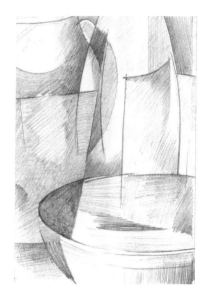

Abstract *Many abstract results evolve through a process of simplification. Here, I took a small section of a still life group, keeping to the main shapes I could see, irrespective of whether these were parts of the object, background shapes or shadows. In fact, this idea proved a good exercise in design and composition, working with the distribution of different shapes and tones.*

Onions *The occasional straightforward piece of observation drawing is good practice, even if you normally work with an entirely different approach. A subject like this encourages you to look carefully and strive for accurate representation.*

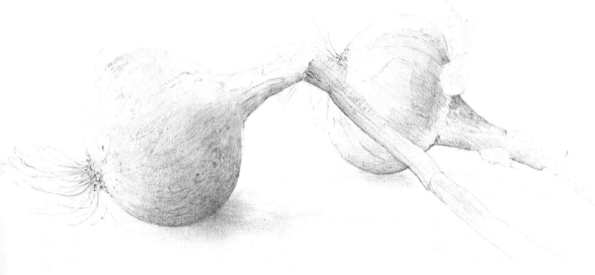

Forest Track –
Step-by-Step (1–3)

Step 1 *Collecting reference material in your sketchbook will provide you with one source of information and ideas. My charcoal drawing of this forest track is a sketchbook study made for this purpose.*

Using a thin stick of charcoal, I started by setting out the main composition loosely. I used a long stick of charcoal held half-way up, letting it flow quite freely across the paper; there is no need for anything too precise at this stage. The slightly cloudy sky was indicated by a few horizontal lines. Where I felt the charcoal was a little strong in tone, I simply smudged it with my fingers.

Step 2 *Particularly in a sketchbook study such as this, I prefer to develop the whole drawing at the same pace. So I worked over the drawing again, starting with the sky. This is blended in and, similarly, most of the original charcoal lines in the other areas were smudged too so as to form a general tone over which to work. I noted where highlights were needed and ensured that these areas were kept white. These general tones were then worked into with a charcoal pencil to begin to establish more recognizable outlines and forms.*

Step 3 *To give more impact, and as a more accurate reference to what was seen, the darker tones were strengthened with stick charcoal and further definition and detail added with the charcoal pencil. The sky effect was modified with a putty eraser.*

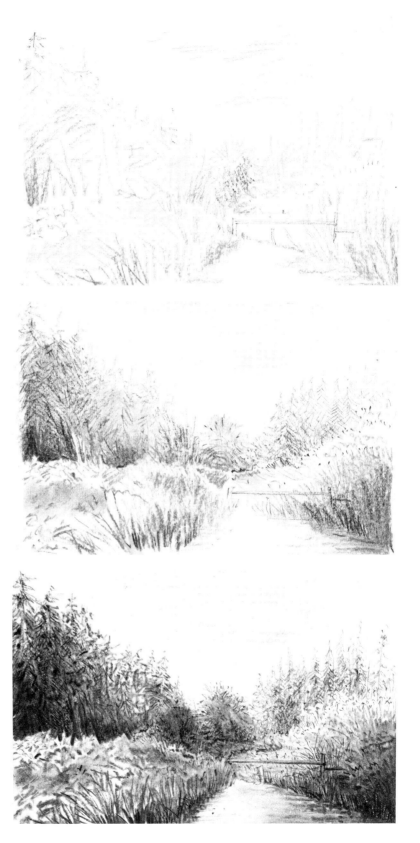

Using a Sketchbook

Artists use their sketchbooks in various ways, but a sketchbook is not generally the place for highly finished drawings. Sometimes – for example, if you are drawing part of a landscape – you may get really involved with the idea and want to go on and make a detailed study of it, while at other times, careful drawings in your sketchbook will give good reference material for a larger work. However, in the main your sketchbook will be used for collecting ideas, solving problems, experimenting, practising techniques and having some fun!

So, think of your sketchbook as a place for uninhibited ideas and experiments. Use it every day if you can, if only for a ten-minute sketch; it is one of the best ways of keeping in touch with drawing, and aiding your improvement and development. It does not matter if some ideas are not entirely successful – you need not show these books to anyone else! The important thing is to maintain an involvement with drawing and not to be afraid to try out fresh techniques and ideas. An A4 cartridge sketchbook will be fine to start with and will suit all the techniques on page 76.

Garden Corner *Sometimes you will have only a few minutes to jot something down. Sketching is often a process of assessing, simplifying and capturing the essentials of an idea in a sort of personal visual shorthand. Just the broadest indication of the subject will usually be enough to jog your memory so that, if you wish, you can develop the drawing in more detail later. This fibre-tip pen sketch took me only about two minutes, but there is sufficient information here to remind me of the idea, such that, using a combination of fact, memory and imagination, I could develop it into a finished drawing.*

Gatepost *All the sketches on these two pages were made in my garden. Each one shows a slightly different technique or approach. This study of another garden corner around an old stone gatepost is in strong contrast to the lightning sketch above. Here, using a B and a 4B pencil, I took my time and examined the various tones, textures and details much more carefully.*

Studies such as this make attractive little drawings and additionally provide plenty of reference information. Working from a study like this I can incorporate the idea into a larger drawing, translate it into colour, or try it in a different medium. At the same time, this sort of sketch is good practice at observed drawing and developing technique. Remember when sketching to look for the main shapes and tones, and to aim for the essential elements of the idea.

Using a Sketchbook

Flowers *The sketchbook is ideal for this sort of analytical approach. Here I concentrated on a single subject but looked at it from a variety of viewpoints and examined different parts of it to discover as much as I could about it.*

This sort of sketch is useful preliminary work towards a final, resolved drawing. It helps you to get to know your subject and sort out any problems regarding its structure, shape, detail, characteristics and so on.

Shrubs *The choice of medium is often the key factor in how you make the sketch. Some media, such as pencils, might encourage a fussier approach because marks can be erased and altered, and elaborate detail work is possible. Other media, such as pens and pastels, will urge you to adopt a freer and more spontaneous approach. In this pen sketch I looked at the overall arrangement of different shapes and textures.*

Sketching Outdoors

Because you need to draw from the actual subjects as much as possible, most of your sketching will be done outside. Here is a list of things you might need for sketching trips:

■ Sketchbook or various sheets of paper and a board to press on.
■ Pencils, pens, charcoal, pastels and a wash medium such as watercolour paints or water-soluble pencils.
■ Small screwtop bottle of water.
■ Brushes, pencil sharpener or knife, putty eraser and other items such as fixative, cloth, bulldog clips and so on as required.
■ Folding stool or something to sit on.
■ Rucksack or bag.
■ Suitable clothing, food and drink.

See also page 7.

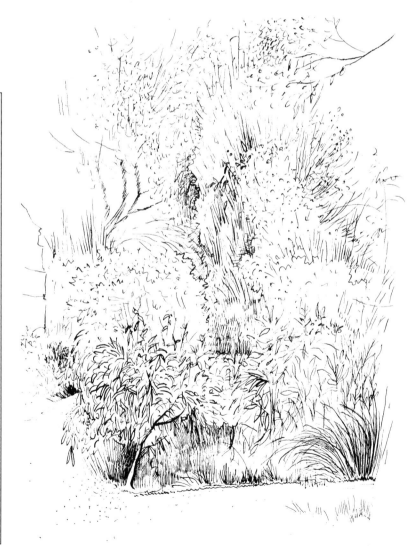

Sketching Techniques

Plant *This is an example of a line and wash technique. Start with a quick outline drawing if you wish, or simply block in the shapes directly with a brush and thin wash. When this is dry, add further lines for definition, details and shading. Here, fibre-tip pen lines were added to an initial wash drawing made with diluted Indian ink.*

Lane *A soft pencil medium, such as a 6B drawing pencil, carpenters' pencil, graphite stick or sketching pencil, is good for capturing the essence of a scene very quickly. This sketch was made in just a few minutes with a 6B pencil.*

Goose *The quickest yet not necessarily the easiest sketching technique is the telling use of line, ideal for 'fleeting' subjects, such as moving animals, crowd scenes and so on. Use the line sensitively, giving weight to the more dominant parts. Most media are suitable.*

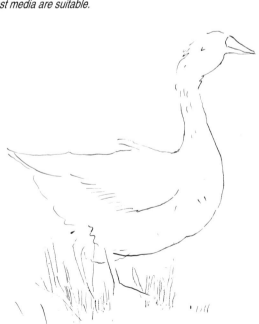

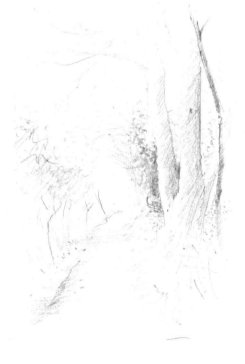

Sketching Techniques

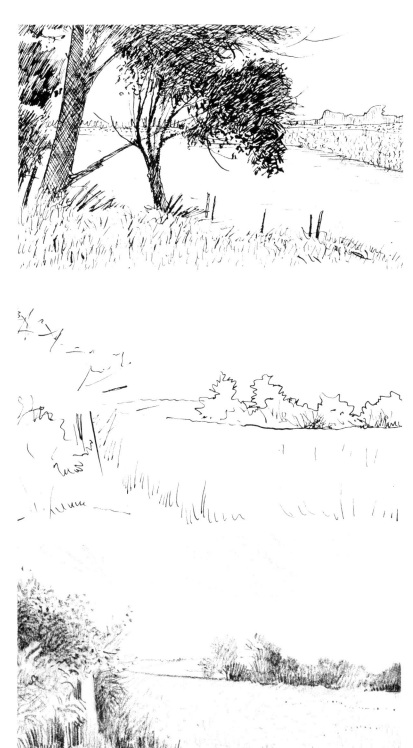

Trees and Lake *Another prerequisite for sketching is that you want to travel light and carry minimal equipment. For this drawing, all I needed apart from my pocket sketchbook was a mapping pen and a small bottle of Indian ink. I used the type of mapping pen in which the nib can be pulled out and reversed, so that it is protected by the holder when being carried around.*

Sometimes there is more time to spend on a sketch, and when this is the case (as in this pen and ink sketch) you can choose a technique and approach which will help you develop the idea in a little more detail than usual. Even so, the emphasis must be on creating an impression of the scene rather than precise detail.

Meadows (1) *Small roughs such as this are extremely useful for planning a large and more detailed composition. Such a sketch will take only a couple of minutes to complete, and so it is possible to make a series of quick 'try-outs' from different viewpoints, consequently providing yourself with various alternative ideas to evaluate.*

Work freely and spontaneously. For this sketch I first used some very loosely drawn pencil lines and then added some pen lines, using a fineline fibre-tip. The pen lines resolve the shapes slightly better and give a clearer indication of the general composition.

Meadows (2) *This shows an alternative sketching technique for the same subject – this time made with a charcoal pencil. Like the best sketching methods, charcoal pencil doesn't encourage rubbing out and therefore prevents you becoming too fussy. Also, as all you need is a small, pocket sketchbook and a pencil, you certainly won't be weighed down with cumbersome equipment!*

Notice how I used the pencil on its side for soft, broad strokes (as for the sky) and combined these with hatched, dotted and more intense lines.

Evolving an Idea

As you have worked through this book you will have noticed that drawings can be made for a variety of reasons. In some drawings, a simple sketch of a few lines is sufficient to check the shape or get the information we want. On other occasions, we may need more detailed drawings for reference or simply draw for the sake of it, taking advantage of the opportunity to express our feelings about a particular scene or subject. Sometimes there is a specific theme which intrigues us and which we may decide to resolve in a more elaborate way, working through various stages towards a definite conclusion, perhaps involving a grander scale and greater detail than usual.

Ideas which excite and inspire us can be explored in a number of ways, using colour and different techniques, as well as various methods of approach and modes of expression. This is where the discovery I talked about in the Introduction really comes into play and can lead to many interesting results. Projects of this kind will need careful planning and you may need to work through quite a few stages to reach the final result. The summary on page 79 outlines important points to consider. Remember to strike a balance between the amount of planning and preparation, leaving room for some originality and discovery in the finished drawings.

Lock Gate (1) *These pages show a sequence of preliminary and reference drawings for a particular theme. They were made on location as starting points for more detailed studio drawings.*

Some initial sketches such as this are good for getting a 'feel' for the subject, and for examining different viewpoints and possible composition alternatives. This is a pen-line sketch with some tone added with a carpenters' pencil.

Lock Gate (2) *The success of an idea doesn't just depend on your skill at handling the medium and conveying an accurate representation of what you see; let some of your personality and feelings show in the drawing too. Choosing an unusual angle, viewpoint or composition will also give the drawing some impact.*

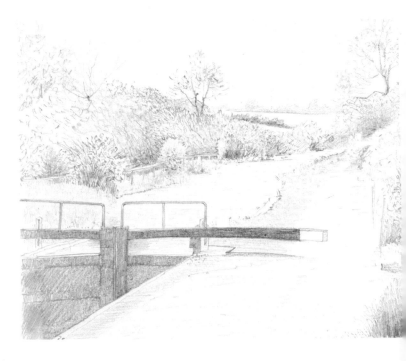

Evolving an Idea

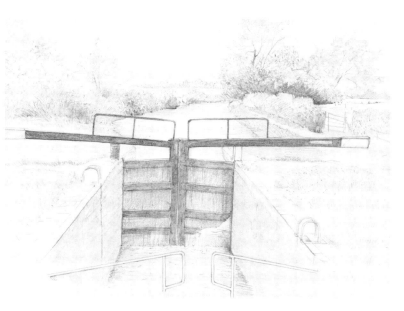

Lock Gate (3) *This is the same lock as in (2) but drawn from a different viewpoint. Whilst the previous drawing has a strong diagonal composition, this one is rather symmetrical, although I tried to offset this to some extent with the foreground railings and the curve of the canal off to the top right. These drawings were made with a soft pencil, which I find allows me to work quickly in both tone and detail.*

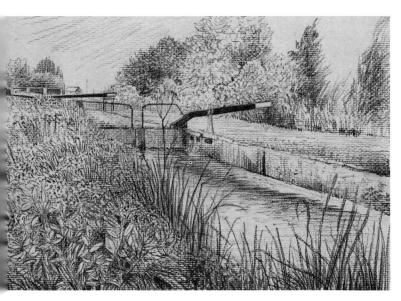

Lock Gate (4) *Here, I tried a different approach, using charcoal and charcoal pencil on grey Artemedia paper. The texture of this paper holds the charcoal well and helps to bring out various effects.*

These drawings, with some supporting photographs, give me plenty of reference material from which to work. I prefer the composition of (4), but would like to work it up in colour, probably using pastel.

Summary

For a thematic project leading to a specific result, you may have to consider the following stages of working:

■ **Aims.** Think about your subject matter and the sort of impact and emphasis you want to achieve. If helpful, make notes, thumbnail sketches, and rough plans and ideas.

■ **Research.** Make some first-hand sketches and studies to provide you with all the necessary information. Refer to Sketching Techniques, (pages 76–7) and the section on colour (pages 49–64) to check on useful media and techniques.

■ **Preparation.** The paper may need stretching, dry-tinting or preparing in some other way before you start work on the drawing. Make sure that you have all the materials and equipment you will need to complete the drawing. Paper stretching is explained on page 9.

■ **Drawing.** Think about how best to evolve the drawing. Work in stages. The step-by-step examples in this book show various methods of approach.

■ **Evaluation.** When you have finished, make an assessment of your drawing. How successful is it in terms of your original aims and intentions? Don't overwork it, but consider whether there are any areas that would benefit from further attention.

Remember to use fixative on any media which are likely to smudge (*see* page 20).

CONCLUSION

The principal aim of this book has been to introduce you to the main drawing media and techniques, as well as those important devices and considerations such as perspective, composition and observation which help make drawings work successfully. At various stages in the book I have stressed the need to experiment and practise. This is essential when we first begin to develop an interest in drawing, and it remains so. No doubt there have been those media and techniques which you have not liked and which have not been successful, but it is vital to have a wide general knowledge of drawing on which to build. This will involve looking at the drawings of other artists – the not-so-famous as well as the famous – in addition to learning from various exercises, practices and, of course, each actual drawing you make.

The scope of drawing is obvious; with different media, styles, emphasis and approaches there is something for everyone. However, before you start to specialize and develop your own style, let me stress some final points: whatever aspect of drawing you aim to explore, observation is always important and it is therefore useful to return occasionally to some straightforward observation drawing; your drawing is more likely to make sound development if you work in a way which is open to new ideas and techniques; and learn from mistakes and persevere – do not expect everything to work out right the first time!

Finally, don't just keep your best drawings, keep them all. It helps to look through what you have done now and again so that you can evaluate your progress by comparing every drawing. Keep the completed drawings in a strong folio or store them flat in drawers. Mount and frame some of the best for display – after all, drawings are meant to be looked at and enjoyed, just as the act of drawing itself will bring its own rewards.

First published in 1995 by
The Crowood Press Ltd
Ramsbury, Marlborough
Wiltshire SN8 2HR

British Library Cataloguing in Publication Data

A catalogue record for this book is available from the British Library

ISBN 1 85223 865 8

Picture credits
All drawings and photographs are by the author

Printed and bound in Great Britain by BPC Hazell Books Ltd
A member of The British Printing Company Ltd